AMERICAN
IMPRESSIONISM

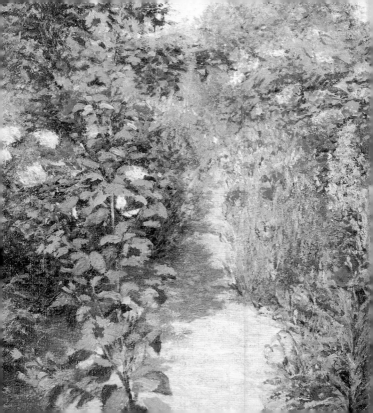

Impressionist Picture of a Garden

Give me sunlight, cupped in a paintbrush,
And smear the red of peonies
Over my garden.
Splash blue upon it,
The hard blue of Canterbury bells,
Paling through larkspur
Into heliotrope,
To wash away among forget-me-nots.
Dip red again to mix a purple,
And lay on pointed flares of lilacs against
 bright green.
Streak yellow for nasturtiums and marsh
 marigolds
And flame it up to orange for my lilies. . . .
Fill up with cobalt and dash in a sky
As hot and heavy as you can make it;
Then tree-green pulled up into that
Gives a fine jolt of color.
Strain it out,
And melt your twigs into the cobalt sky.
Toss on some Chinese white to flash the clouds,
And trust the sunlight you've got in your paint.
There is the picture.

— Amy Lowell

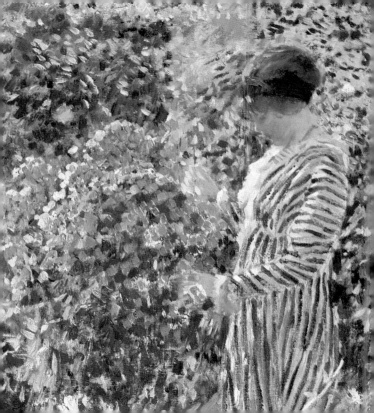

AMERICAN IMPRESSIONISM

William H. Gerdts

A TINY FOLIO™
Abbeville Press Publishers
New York London Paris

For Ray and Margaret Horowitz,
leaders of American Impressionism,
and for Abbie, again and always

Front cover: Detail of William Merritt Chase, *The Fairy Tale*, 1892. See page 114.
Back cover: Childe Hassam, *Allies Day, May 1917*, 1917. See page 307.
Spine: Detail of Edmund Tarbell, *In the Orchard*, 1891. See page 101.
Page 2: Detail of John Leslie Breck, *Garden at Giverny*, c. 1887. Oil on canvas, 18 x 22 in. (45.7 x 55.9 cm). Private collection.
Frontispiece: Lady in a Garden, by Frederick Frieseke, c. 1912. See page 262.
Page 8: Detail of William Merritt Chase, *End of the Season*, c. 1885. See page 26.
Page 10: Detail of Mary Cassatt, *Baby Reaching for an Apple*, 1893. See page 22.
Page 13: Detail of Mary Cassatt, *Lydia in a Loge, Wearing a Pearl Necklace*, 1879. See page 16.
Page 30: Detail of Theodore Butler, *The Artist's Family*, 1895. See page 54.
Page 32: Detail of John Singer Sargent, *Claude Monet at the Edge of a Wood*, c. 1887. See page 60.
Page 35: Detail of Theodore Robinson, *The Wedding March*, 1892. See page 57.
Page 74: Detail of Childe Hassam, *The Room of Flowers*, 1894. See page 90.
Page 77: Detail of Edmund Tarbell, *In the Orchard*, 1891. See page 101.
Page 106: Detail of William Merritt Chase, *Near the Beach, Shinnecock*, 1895. See page 115.
Page 109: Detail of William Merritt Chase, *The Fairy Tale*, 1892. See page 114.
Page 118: Detail of Childe Hassam, *Crystal Palace, Chicago Exposition*, 1893. See page 124.
Page 120: Detail of Theodore Robinson, *Chicago Columbian Exposition*, 1894. See page 125.
Page 123: Detail of Otto Stark, *The Seiner*, 1900. See page 131.
Page 132: Detail of Childe Hassam, *Piazza di Spagna, Rome*, 1897. See page 141.
Page 135: Detail of J. Alden Weir, *The Red Bridge*, 1895. See page 151.
Page 154: Detail of Frank Benson, *Lady Trying on a Hat*, 1904. See page 165.
Page 156: Detail of Willard Metcalf, *Gloucester Harbor*, 1895. See page 167.
Page 159: Detail of Thomas Wilmer Dewing, *The Hermit Thrush*, c. 1893. See page 162.
Page 170: Detail of Childe Hassam, *Sunset at Sea*, 1911. See page 174.
Page 173: Detail of Willard Metcalf, *The Poppy Garden*, 1905. See page 268.
Page 186: Detail of Philip Leslie Hale, *The Crimson Rambler*, n.d. See page 193.
Page 189: Detail of Edward Rook, *Bradbury's Mill, Swirling Waters*, c. 1917. See page 217.
Page 191: Detail of Ernest Blumenschein, *Sangre de Cristo Mountains*, 1925. See page 246.
Page 256: Detail of Frederick Frieseke, *Hollyhocks*, c. 1914. See page 263.
Page 259: Detail of Guy Rose, *The Blue Kimono*, c. 1909. See page 268.
Page 278: Detail of Ernest Lawson, *Harlem River*, c. 1910. See page 282.
Page 281: Detail of Marsden Hartley, *Carnival of Autumn*, 1908–9. See page 304.

For copyright and Cataloging-in-Publication Data, see page 319.

CONTENTS

I.

PRELUDE, TO 1886

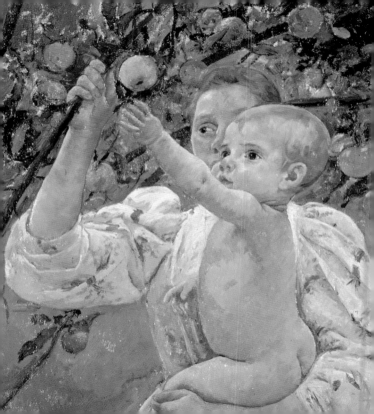

I.
AMERICANS AND IMPRESSIONISM,
AT HOME AND ABROAD

The term Impressionism was subject to many interpretations in America, especially in its earliest stages. It was not until the late 1880s that American artists and critics grasped its salient characteristics: pure, prismatic color laid directly on the canvas; an absence of the neutral tones and dark shadows used in traditional modeling; and an emphasis on depicting everyday life, captured with an immediacy enhanced by the transient effects of light and atmosphere.

Claude Monet and his fellow Impressionists exhibited as a group in Paris almost annually from 1874 through 1886. Relatively few of the hundreds of Americans studying there, however, were initially interested in the work of this avant-garde, and American critical evaluation of the movement was confounded by an indecision as to what Impressionism was. Many critics denounced Impressionism as crude and materialistic; others, such as the landscapist George Inness, condemned its unpolished spontaneity. Attempting to identify American practitioners of the new aesthetic, some critics incorrectly pointed

to the brightly lit watercolors of Winslow Homer and the misty, Tonalist canvases of James McNeill Whistler. These artists shared the Impressionists' concern with creating a palpable atmosphere but did not use light to dissolve form into color, as true Impressionism dictated.

The first—and perhaps the greatest—American Impressionist to be accurately identified was Mary Cassatt, who lived in Paris for most of her life. Cassatt's *Lydia in a Loge, Wearing a Pearl Necklace* (opposite and page 16) of 1879 may well be the first truly Impressionist painting by an American to be recognized and discussed as such. Although Cassatt's own style did not remain consistently Impressionist, she did help popularize Impressionism in the United States through her personal influence on such American collectors as Louisine Havemeyer.

The 1886 exhibition organized in New York by the Parisian art dealer Paul Durand-Ruel was the turning point for Impressionism in America. Numerous canvases by Edgar Degas, Edouard Manet, Claude Monet, Berthe Morisot, Camille Pissarro, Auguste Renoir, and Alfred Sisley, as well as two by Cassatt, were shown together for the first time in the United States. The exhibition was a commercial success, and its reception by critics, although mixed, was extensive and serious. After 1886 American art would never be the same.

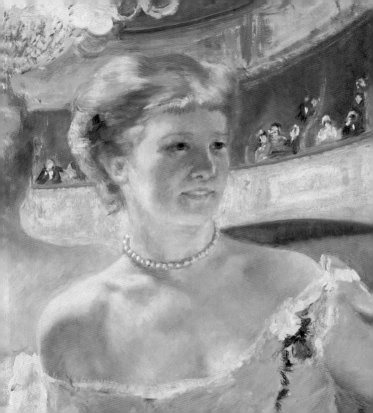

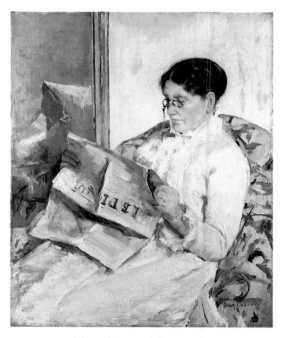

MARY CASSATT (1844–1926).
Reading "Le Figaro," 1878. Oil on canvas, 39¾ x 32 in.
(101 x 81.3 cm). Private collection.

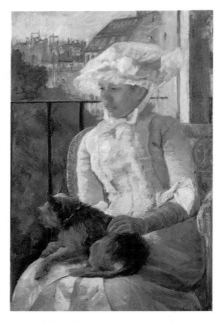

MARY CASSATT (1844–1926).
Susan with Dog on a Balcony, 1883. Oil on canvas,
39½ x 25½ in. (100.3 x 64.8 cm).
The Corcoran Gallery of Art, Washington, D.C.

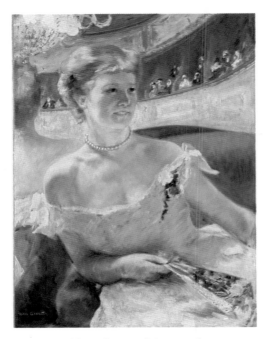

MARY CASSATT (1844–1926).
Lydia in a Loge, Wearing a Pearl Necklace, 1879. Oil on canvas,
31⅝ x 23 in. (80.3 x 58.4 cm). Philadelphia Museum of Art.

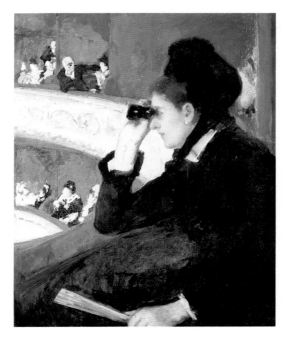

MARY CASSATT (1844–1926).
At the Opera, 1880. Oil on canvas, 31½ x 25½ in.
(80 x 64.8 cm). Museum of Fine Arts, Boston.

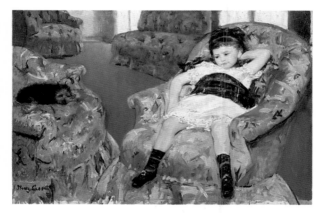

MARY CASSATT (1844–1926).
Little Girl in a Blue Armchair, 1878. Oil on canvas,
35¼ x 51⅛ in. (89.4 x 129.8 cm).
National Gallery of Art, Washington, D.C.

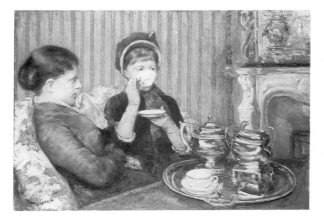

MARY CASSATT (1844–1926).
Cup of Tea, c. 1880. Oil on canvas, 25½ x 36½ in.
(64.8 x 92.7 cm). Museum of Fine Arts, Boston.

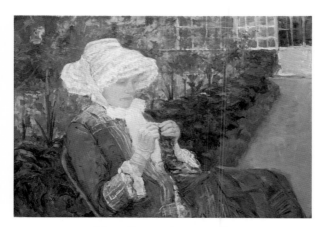

MARY CASSATT (1844–1926).
Lydia Crocheting in the Garden at Marly, 1880.
Oil on canvas, 26 x 37 in. (66 x 94 cm).
The Metropolitan Museum of Art, New York.

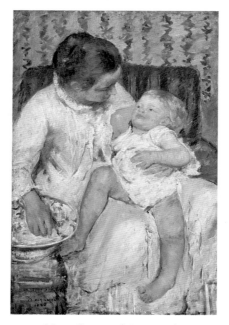

MARY CASSATT (1844–1926).
Mother About to Wash Her Sleepy Child, 1880.
Oil on canvas, 39½ x 25¾ in. (100.3 x 65.4 cm).
Los Angeles County Museum of Art.

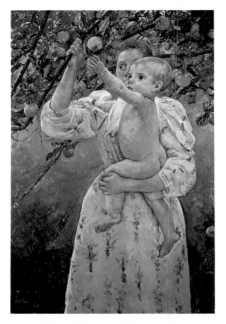

MARY CASSATT (1844–1926).
Baby Reaching for an Apple, 1893. Oil on canvas,
39½ x 25¼ in. (100.3 x 64.1 cm).
Virginia Museum of Fine Arts, Richmond.

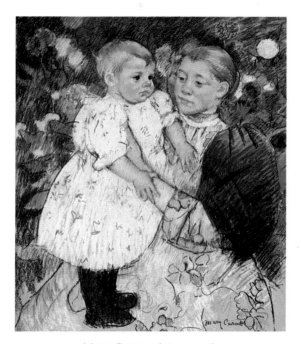

MARY CASSATT (1844–1926).
In the Garden, 1893. Pastel on paper, 28¾ x 23⅝ in.
(73 x 60 cm). The Baltimore Museum of Art.

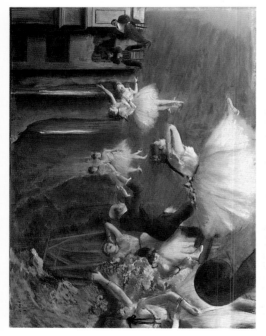

EDGAR DEGAS (1834–1917).
The Rehearsal on the Stage, c. 1874–78. Pastel over brush and ink drawing on paper, 21 x 28½ in. (53.3 x 72.4 cm). The Metropolitan Museum of Art, New York.

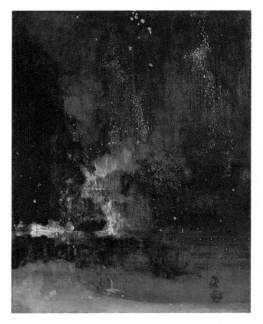

JAMES MCNEILL WHISTLER (1834–1903).
Nocturne in Black and Gold—The Falling Rocket, c. 1874.
Oil on oak panel, 23¾ x 18⅜ in. (60.3 x 46.7 cm).
The Detroit Institute of Arts.

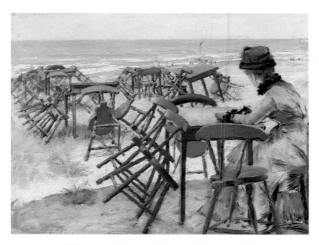

WILLIAM MERRITT CHASE (1849–1916).
End of the Season, c. 1885. Pastel on paper, 13¾ x 17¾ in.
(34.9 x 45.1 cm). Mount Holyoke College Art Museum,
South Hadley, Massachusetts.

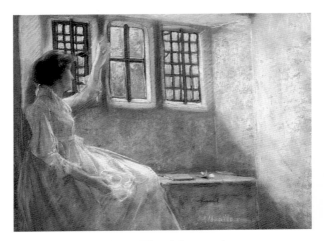

J. ALDEN WEIR (1852–1919).
The Windowseat, 1889. Pastel and pencil on paper,
13¼ x 17½ in. (33.7 x 44.5 cm). Private collection.

CLAUDE MONET (1840–1926).
Meadow with Haystacks near Giverny, 1885. Oil on canvas, 29⅛ x 36¾ in. (74 x 93.3 cm). Museum of Fine Arts, Boston.

JOHN TWACHTMAN (1853–1902).
Haystacks at Edge of Woods, 1890s. Pastel on paper, 9 x 12½ in. (22.9 x 31.8 cm). National Museum of American Art, Smithsonian Institution, Washington, D.C.

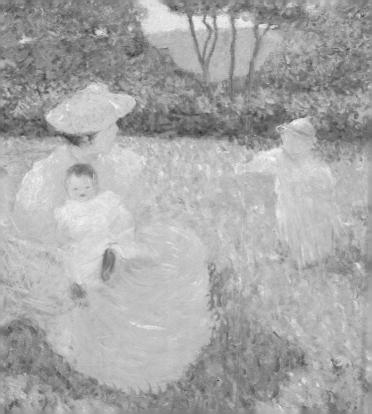

II.

RISING PERCEPTIONS,

1886–1893

2.

GIVERNY: THE FIRST GENERATION

In 1883 Claude Monet moved to Giverny, where he was joined roughly four years later by a group of American painters in search of a summer venue. Reports claim that the colonists discovered Giverny by chance, but they surely were aware that Monet was there. The interaction among these artists—John Leslie Breck, Willard Metcalf, Louis Ritter, Theodore Robinson, Theodore Wendel, and others—was probably as important an influence on them as Monet's presence. In the late 1880s their art was developing toward greater freedom and colorism, a development that would have occurred whether they painted in the shadow of Monet or not.

The most significant and influential of the American Givernois was Theodore Robinson. Though he was branded a leader of avant-garde Impressionism back home, Robinson's paintings of the period—landscapes and figure studies in the landscape—illustrate only a qualified conversion to the Impressionist aesthetic. In many works the colors became more intense, but the chromatic range remained limited and the compositional structure pronounced; spontaneity resided in the application of paint.

Robinson became an intimate friend of Monet's; his sun-drenched *Wedding March* (opposite and page 42) commemorates the marriage of Monet's stepdaughter to another American painter, Theodore Butler.

The celebrated portraitist John Singer Sargent also went to Giverny in 1887, to visit Monet. Impressionism was Sargent's primary concern for only a short while, however. His most Impressionist pictures are those depicting his sister Violet walking in sunlight and his outdoor paintings done in 1888–89, in which vegetation is rendered in the spiky, quill-like brush strokes that became a hallmark of Sargent's Impressionist technique.

Lilla Cabot Perry established an enduring friendship with Monet beginning in 1889, when she first went to Giverny and took an Etretat view by Monet back to Boston, one of his first works seen there. Perry subscribed fully to Monet's aesthetic, particularly in her landscapes, where she applied the Divisionist technique and the full color range of Impressionism. As with so many Americans, in her figure paintings Perry maintained a firm academic stance, with accurate drawing and well-modeled forms. After Monet died in 1926, Perry wrote "Reminiscences," the fullest—and warmest—recollection of the great French Impressionist who so influenced American art.

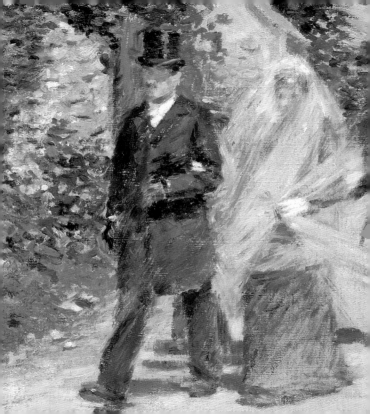

THEODORE ROBINSON (1852–1896).
Bird's Eye View of Giverny, France, 1889.
Oil on canvas, 25¾ x 32 in. (65.4 x 81.3 cm).
The Metropolitan Museum of Art, New York.

THEODORE ROBINSON (1852–1896).
A Farm House in Giverny, c. 1890. Oil on canvas, 23 x 40¼ in.
(58.4 x 102.2 cm). Courtesy of Spanierman Gallery, New York.

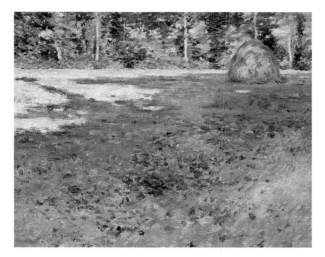

THEODORE ROBINSON (1852–1896).
Afternoon Shadows, 1891. Oil on canvas,
18¼ x 21⅞ in. (46.4 x 55.6 cm). Museum of Art,
Rhode Island School of Design, Providence.

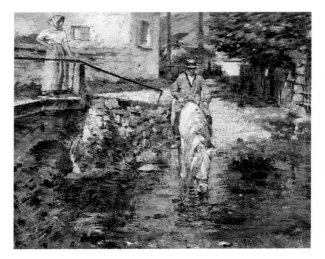

THEODORE ROBINSON (1852–1896).
Père Trognon and His Daughter at the Bridge, 1891. Oil on canvas,
18¼ x 22⅛ in. (46.4 x 56.1 cm). Terra Foundation for the Arts.

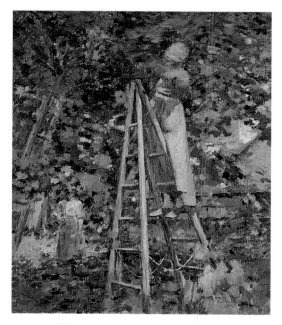

THEODORE ROBINSON (1852–1896).
Gathering Plums, 1891. Oil on canvas, 22 x 18 in.
(55.9 x 45.7 cm). Georgia Museum of Art,
The University of Georgia, Athens.

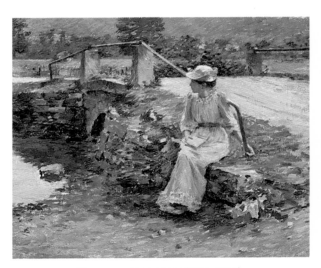

THEODORE ROBINSON (1852–1896).
La Débâcle, 1892. Oil on canvas,
18 x 22 in. (45.7 x 55.9 cm).
Scripps College, Claremont, California.

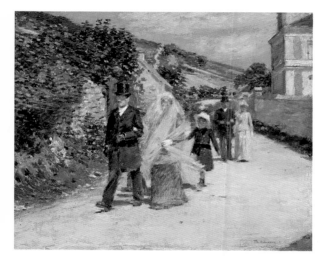

Theodore Robinson (1852–1896).
The Wedding March, 1892. Oil on canvas, 22 x 26 in.
(55.9 x 66 cm). Terra Museum of American Art, Chicago.

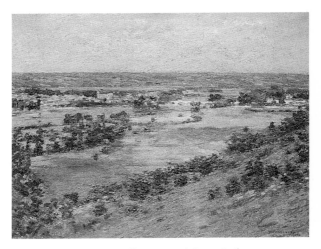

THEODORE ROBINSON (1852–1896).
Valley of the Seine, 1892. Oil on canvas, 25 x 32½ in.
(63.5 x 82.6 cm). Addison Gallery of American Art,
Phillips Academy, Andover, Massachusetts.

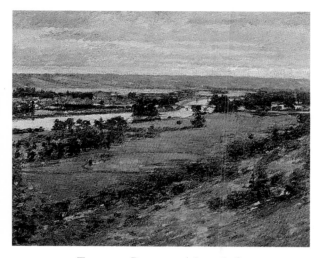

THEODORE ROBINSON (1852–1896).
Valley of the Seine, 1892. Oil on canvas, 26 x 32 in.
(66 x 81.3 cm). Maier Museum of Art,
Randolph-Macon Woman's College, Lynchburg, Virginia.

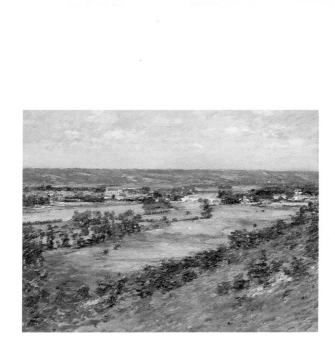

THEODORE ROBINSON (1852–1896).
Valley of the Seine from Giverny Heights, 1892.
Oil on canvas, 25⅞ x 32⅛ in. (65.8 x 81.5 cm).
The Corcoran Gallery of Art, Washington, D.C.

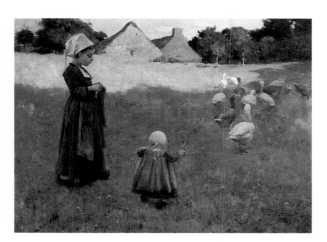

WILLARD METCALF (1858–1925).
Goose Girl, 1884. Oil on canvas, 18 x 24 in. (45.7 x 60.1 cm).
Private collection.

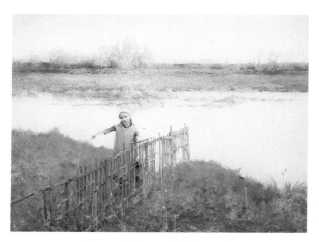

WILLARD METCALF (1858–1925).
Sunset at Grèz, 1885. Oil on canvas, 34 x 43⅝ in.
(86.4 x 110.7 cm). Hirshhorn Museum and Sculpture Garden,
Smithsonian Institution, Washington, D.C.

LOUIS RITTER (1854–1892).
Barley Field, Giverny, 1887. Oil on canvas, 24 x 39¾ in.
(60.7 x 101 cm). Jeffrey R. Brown.

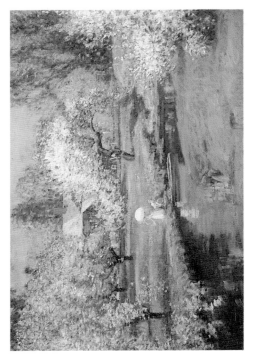

THEODORE WENDEL (1857–1932).
Lady with a Parasol by a Stream, 1889. Oil on canvas, 20 x 30 in. (50.8 x 76.2 cm). Dr. John McDonough.

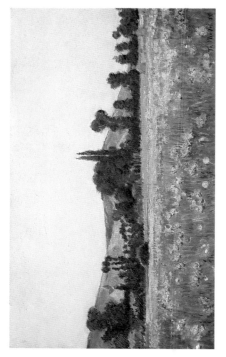

THEODORE WENDEL (1857–1932).
Flowering Fields, Giverny, 1889. Oil on canvas, 12½ x 21½ in.
(31.8 x 54.6 cm). Private collection.

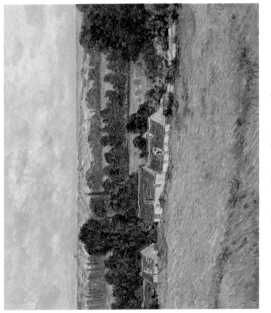

CLAUDE MONET (1840–1926).
Field of Poppies, Giverny, 1885. Oil on canvas, 25⅝ x 28¾ in.
(65.1 x 73 cm). Virginia Museum of Fine Arts, Richmond.

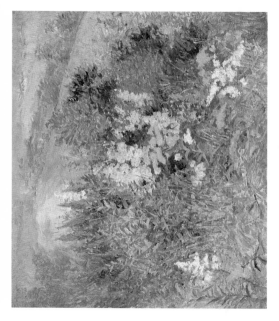

John Leslie Breck (1860–1909).
Rock Garden at Giverny, c. 1887. Oil on canvas, 18 x 22 in.
(45.7 x 55.9 cm). Private collection.

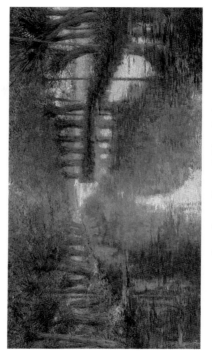

JOHN LESLIE BRECK (1860–1899).
The River Epte, c. 1887. Oil on canvas, 24 x 43¾ in.
(61 x 111.1 cm). Berry-Hill Galleries, New York.

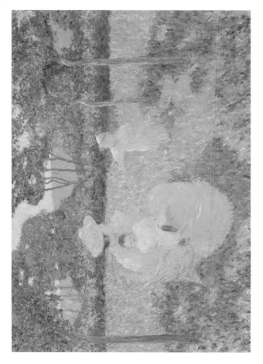

THEODORE BUTLER (1861–1936).
The Artist's Family, 1895. Oil on canvas, 34 x 50 in.
(86.4 x 127 cm). Mr. and Mrs. Al Wilsey, San Francisco.

THEODORE BUTLER (1861–1936).
Grainstacks, Giverny, c. 1897. Oil on canvas, 21¼ x 28¾ in.
(54 x 60.3 cm). The Dixon Gallery and Gardens, Memphis.

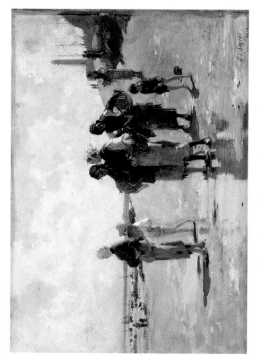

JOHN SINGER SARGENT (1856–1925).
Oyster Gatherers of Cancale, 1878.
Oil on canvas, 31⅛ x 48½ in. (79 x 123.2 cm).
The Corcoran Gallery of Art, Washington, D.C.

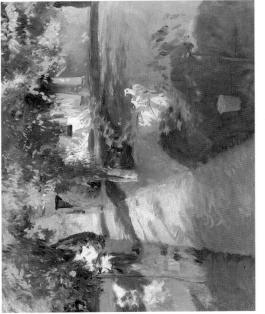

John Singer Sargent (1856–1925).
Millet's Garden, 1886. Oil on canvas, 27 x 35 in.
(68.6 x 89 cm). Private collection.

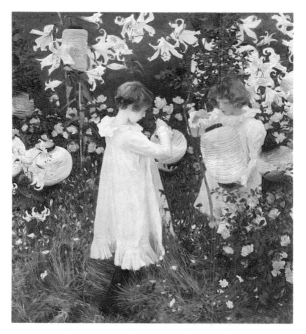

JOHN SINGER SARGENT (1856–1925).
Carnation, Lily, Lily, Rose, 1885–86. Oil on canvas,
68½ x 60½ in. (174 x 153.7 cm). The Tate Gallery, London.

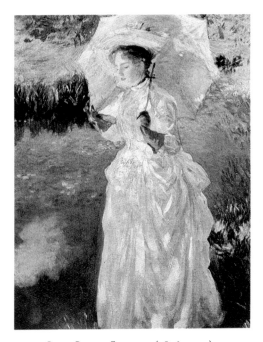

JOHN SINGER SARGENT (1856–1925).
A Morning Walk, c. 1888. Oil on canvas, 26⅜ x 19¾ in.
(67.1 x 42.5 cm). The Ormond Family.

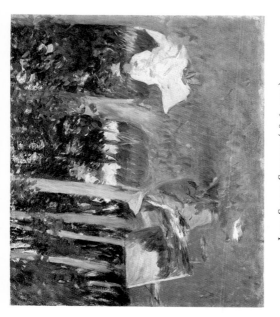

JOHN SINGER SARGENT (1856–1925).
Claude Monet at the Edge of a Wood, c. 1887. Oil on canvas, 21¼ x 25½ in. (54 x 64.8 cm). The Tate Gallery, London.

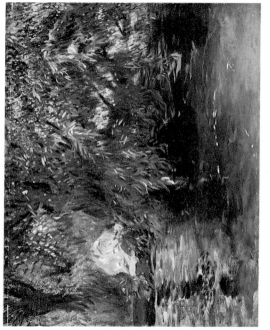

JOHN SINGER SARGENT (1856–1925).
A Backwater, Calcot Mill near Reading, 1888. Oil on canvas,
20⅛ x 27 in. (51.1 x 68.6 cm). The Baltimore Museum of Art.

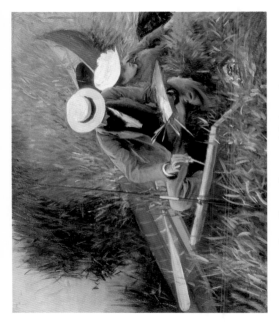

JOHN SINGER SARGENT (1856–1925).
Paul Helleu Sketching with His Wife, 1889. Oil on canvas,
26⅛ x 32⅛ in. (66.3 x 81.5 cm). The Brooklyn Museum.

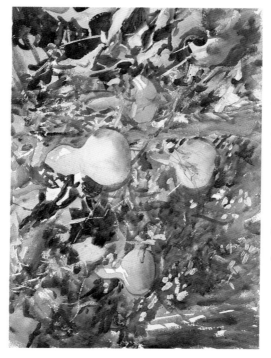

John Singer Sargent (1856–1925).
Gourds, c. 1905–8. Watercolor on paper, 13¾ x 17⅞ in.
(34.9 x 45.5 cm). The Brooklyn Museum.

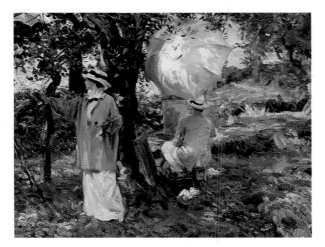

JOHN SINGER SARGENT (1856–1925).
The Sketchers, 1914. Oil on canvas, 22 x 28 in. (55.9 x 71.1 cm).
Virginia Museum of Fine Arts, Richmond.

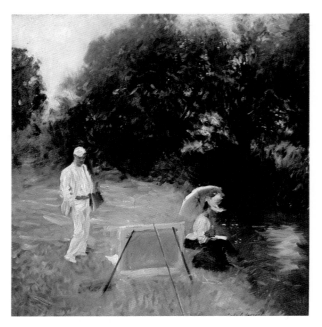

JOHN SINGER SARGENT (1856–1925).
Dennis Miller Bunker Painting at Calcot, c. 1888.
Oil on canvas, 26¾ x 25 in. (67.9 x 63.5 cm).
Terra Museum of American Art, Chicago.

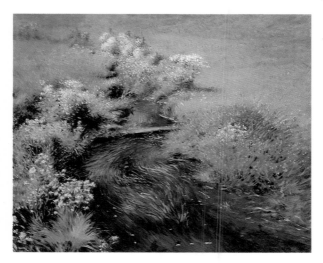

DENNIS MILLER BUNKER (1861–1890).
Wild Asters, 1889. Oil on canvas, 25 x 30 in. (63.5 x 76.2 cm).
Mr. and Mrs. Jared I. Edwards.

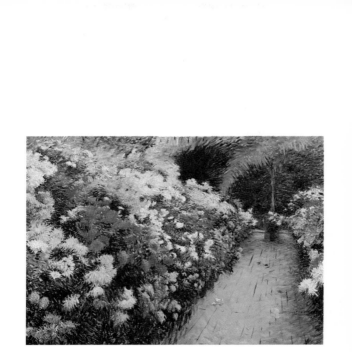

DENNIS MILLER BUNKER (1861–1890).
Chrysanthemums, 1888. Oil on canvas, 35½ x 47⅝ in.
(90.2 x 120.9 cm). Isabella Stewart Gardner Museum, Boston.

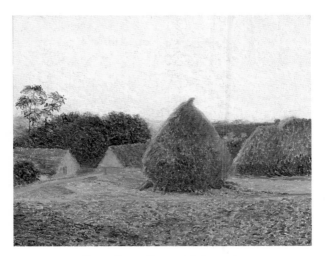

LILLA CABOT PERRY (1848–1933).
Haystacks, Giverny, c. 1896. Oil on canvas, 25¾ x 32 in.
(65.4 x 81.3 cm). Warren Snyder Collection.

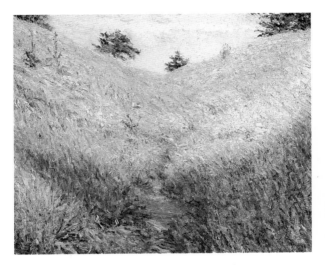

LILLA CABOT PERRY (1848–1933).
Giverny Hillside, n.d. Oil on canvas, 18 x 22 in.
(45.7 x 55.9 cm). Blake and Barbara Tartt.

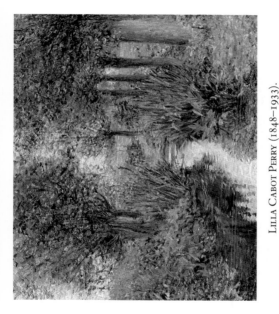

LILLA CABOT PERRY (1848–1933).
A Stream Beneath Poplars, 1890–1900. Oil on canvas,
25¾ x 32 in. (65.4 x 81.3 cm),
Hunter Museum of Art, Chattanooga, Tennessee.

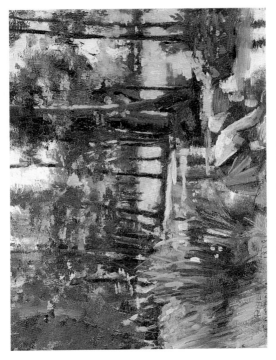

PHILIP LESLIE HALE (1865–1931).
Giverny, 1888. Oil on canvas, 10 x 13 in. (25.4 x 33 cm).
Herbert M. and Beverly Gelfand.

PHILIP LESLIE HALE (1865–1931).
Giverny Garden, c. 1890s. Oil on canvas, 19¼ x 25⅝ in.
(48.9 x 65.1 cm). Norah Hardin Lind.

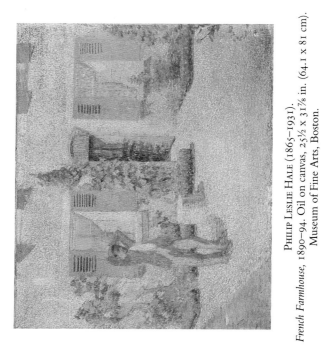

PHILIP LESLIE HALE (1865–1931).
French Farmhouse, 1890–94. Oil on canvas, 25½ x 31⅞ in. (64.1 x 81 cm).
Museum of Fine Arts, Boston.

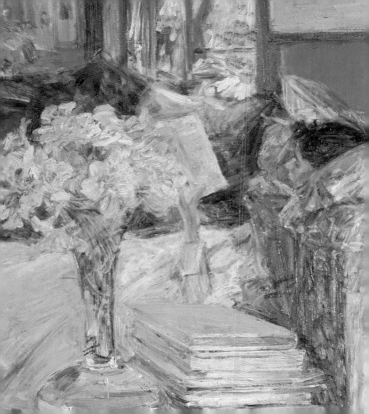

3.

THE EARLY MASTERS

By the early 1890s Childe Hassam had emerged as the most completely Impressionist American painter, a status he is still generally accorded today. He had already become a skilled painter of Tonalist city scenes, usually set at dusk or in the rain, by the mid-1880s, and he continued to incorporate Tonalist planes of color and reflections in his later, more Impressionist pictures. Indeed, very few of the style's pioneers actually started with Impressionism; rather they adapted it to or adopted it in place of an earlier aesthetic.

By 1887 Hassam's colors became lighter and more diverse, the brushwork looser, and the forms more broken. Although he remained true to urban scenes under overcast skies, Hassam also produced bright city views, such as *Grand Prix Day* (page 81), painted in the radiance of full sunlight and filled with the joyousness that characterized so much Impressionist art. The flower-filled landscapes that Hassam painted on Appledore Island—arguably the most beautiful paintings of his career—illustrate the flecked, broken brushwork and full chromaticism of Impressionism.

J. Alden Weir and John Twachtman each developed a unique modified-Impressionist style. Weir was an academically grounded painter of dark still lifes and figure studies who began painting the Connecticut landscape during the 1880s, gradually lightening his palette and becoming involved with Impressionism. Twachtman's idiosyncratic Impressionism suggests the impact of James McNeill Whistler and of Oriental art in its near-abstract sense of design and flattened space. Around 1889 Twachtman began adopting a lighter color range, a looser brush stroke, and a concern for atmosphere, all of which allied his painting with Impressionism.

Boston spawned an important group of figure painters who adopted the new aesthetic, including Frank Benson, Philip Leslie Hale, and Edmund Tarbell. Tarbell, the leader of the group, developed an Impressionism concerned with rich, full summer sunlight but centered on the figure—specifically, on lovely young women.

Another Boston painter, Robert Vonnoh, converted to Impressionism while working at Grèz, a colony dominated by the more traditional peasant landscape paintings by Jules Bastien-Lepage rather than the innovations of Monet. While there Vonnoh produced vibrant landscapes, employing the signature lavenders, violets, and purples of Impressionism. Returning to the United States in 1891, he became an outstanding teacher of Impressionist techniques.

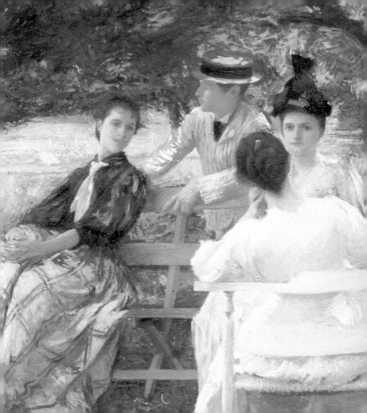

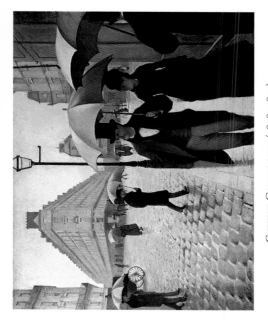

GUSTAVE CAILLEBOTTE (1848–1894).
Paris, A Rainy Day (Intersection of the Rue de Turin and Rue de Moscow), 1877. Oil on canvas, 83½ x 108¾ in. (212.1 x 276.2 cm). The Art Institute of Chicago.

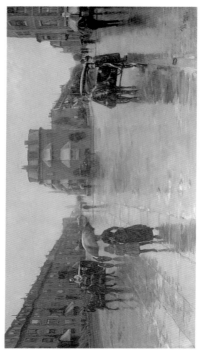

CHILDE HASSAM (1859–1935).
Rainy Day, Columbus Avenue, Boston, 1885. Oil on canvas,
26⅛ x 48 in. (66.3 x 121.9 cm).
The Toledo Museum of Art, Toledo, Ohio.

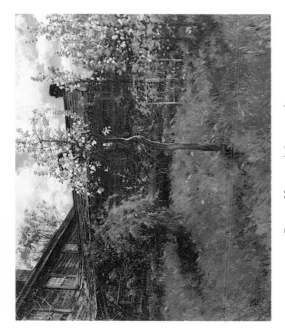

CHILDE HASSAM (1859–1935).
Old House, Dorchester, 1884. Oil on canvas, 16 x 26 in.
(40.6 x 66 cm). U.S. Steel Corporation, Pittsburgh.

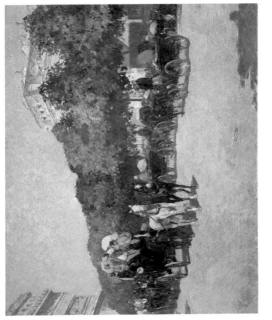

CHILDE HASSAM (1859–1935).
Grand Prix Day, 1887. Oil on canvas, 24 x 31 in.
(61 x 78.7 cm). Museum of Fine Arts, Boston.

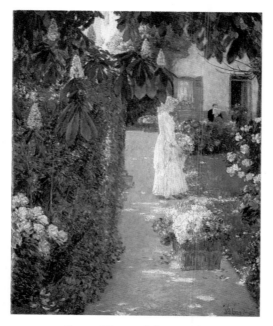

CHILDE HASSAM (1859–1935).
Gathering Flowers in a French Garden, 1888. Oil on canvas,
28 x 21⅝ in. (71.1 x 55.1 cm). Worcester Art Museum,
Worcester, Massachusetts.

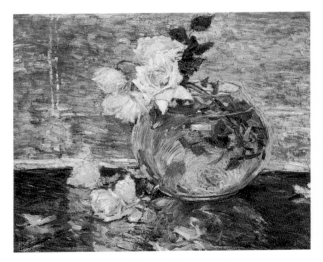

CHILDE HASSAM (1859–1935).
Vase of Roses, 1890. Oil on canvas, 20 x 24¼ in.
(50.8 x 61.6 cm). The Baltimore Museum of Art.

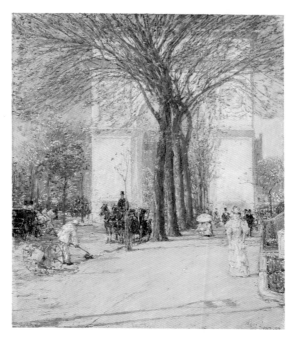

CHILDE HASSAM (1859–1935).
Washington Arch, Spring, 1890. Oil on canvas, 26 x 21½ in.
(66 x 54.6 cm). The Phillips Collection, Washington, D.C.

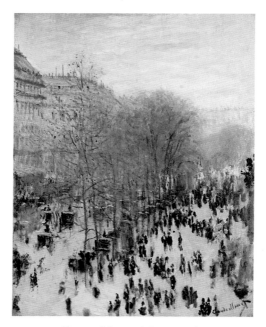

CLAUDE MONET (1840–1926).
Boulevard des Capuchines, Paris (Les Grands Boulevards),
1873–74. Oil on canvas, 31¼ x 23¼ in. (79.4 x 59.1 cm).
The Nelson-Atkins Museum of Art, Kansas City, Missouri.

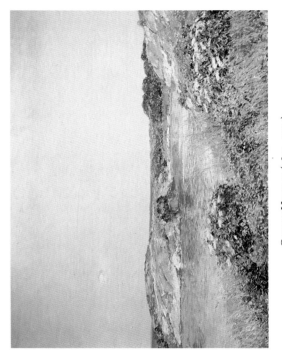

CHILDE HASSAM (1859–1935).
The Little Pond, Appledore, 1890. Oil on canvas, 16½ x 22 in.
(41.9 x 55.9 cm). Daniel P. Grossman Gallery, New York.

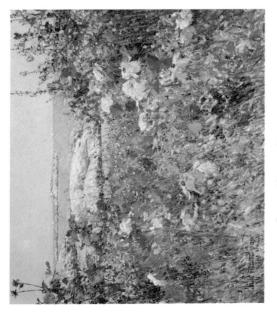

CHILDE HASSAM (1859–1935).
Celia Thaxter's Garden, Isles of Shoals, Maine, 1890. Oil on canvas,
17½ x 21 in. (44.5 x 53.3 cm). Private collection.

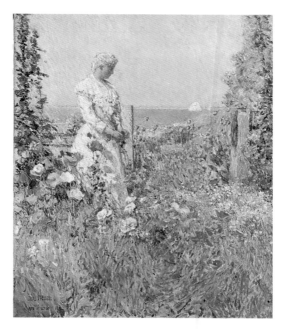

CHILDE HASSAM (1859–1935).
Celia Thaxter in Her Garden, 1892. Oil on canvas,
22⅛ x 18⅜ in. (56.1 x 46.7 cm). National Museum of
American Art, Smithsonian Institution, Washington, D.C.

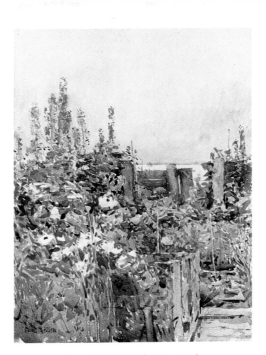

CHILDE HASSAM (1859–1935).
Home of the Hummingbird, 1893. Watercolor on paper,
14 x 10 in. (35.6 x 25.4 cm). Mr. and Mrs. Arthur G. Altschul.

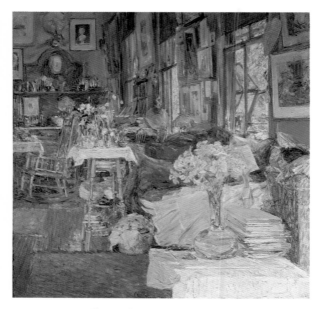

CHILDE HASSAM (1859–1935).
The Room of Flowers, 1894. Oil on canvas, 34 x 34 in.
(86.4 x 86.4 cm). Mr. and Mrs. Arthur G. Altschul.

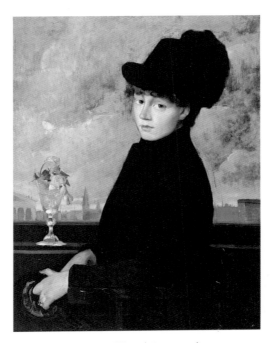

J. Alden Weir (1852–1919).
Against the Window, 1884. Oil on canvas, 36⅛ x 29½ in.
(91.7 x 74.9 cm). Private collection.

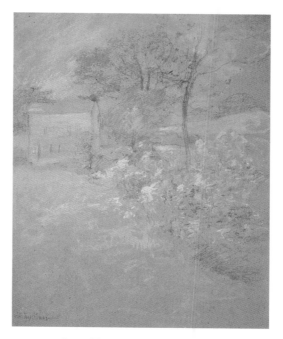

John Twachtman (1853–1902).
Spring, n.d. Pastel on paper, 14 x 11 in. (35.6 x 27.9 cm).
The Phillips Collection, Washington, D.C.

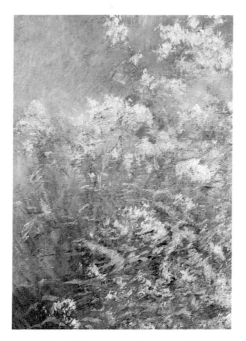

JOHN TWACHTMAN (1853–1902).
Meadow Flowers, 1890s. Oil on canvas, 33⅛ x 22⅛ in.
(84.1 x 56.1 cm). The Brooklyn Museum.

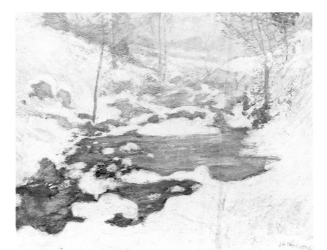

JOHN TWACHTMAN (1853–1902).
Icebound, 1888–89. Oil on canvas, 25½ x 30½ in.
(64.8 x 77.5 cm). The Art Institute of Chicago.

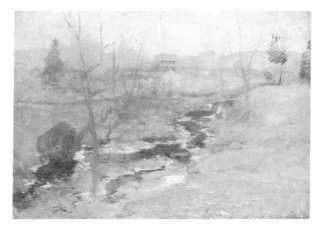

JOHN TWACHTMAN (1853–1902).
End of Winter, 1890s. Oil on canvas, 22 x 30⅛ in.
(55.9 x 76.5 cm). National Museum of American Art,
Smithsonian Institution, Washington, D.C.

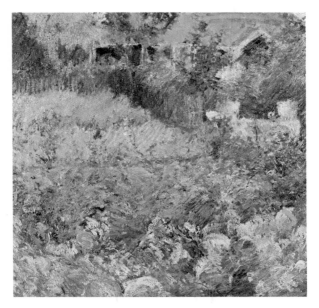

JOHN TWACHTMAN (1853–1902).
Cabbage Patch, probably 1897–98. Oil on canvas, 25 x 25 in.
(63.5 x 63.5 cm). Helen Hyman.

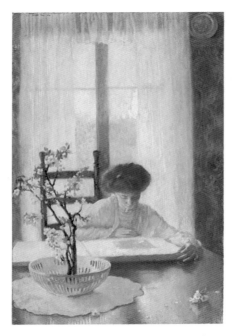

LILLIAN WESTCOTT HALE (1881–1963).
L'Edition de Luxe, 1910. Pastel on paper, 25 x 15½ in.
(63.5 x 39.4 cm). Museum of Fine Arts, Boston.

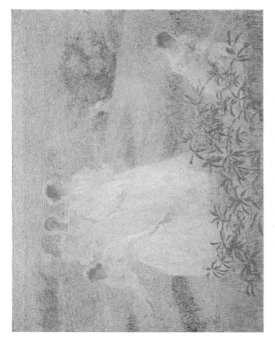

PHILIP LESLIE HALE (1865–1931).
Girls in Sunlight, c. 1892. Oil on canvas, 29 x 39 in.
(73.7 x 99.1 cm). Museum of Fine Arts, Boston.

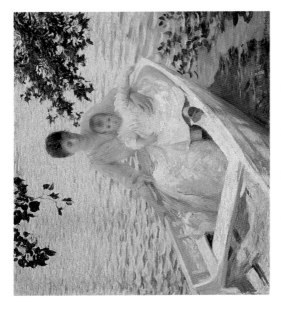

EDMUND TARBELL (1862–1938).
Mother and Child in a Boat, 1892. Oil on canvas, 30 x 35 in.
(76.2 x 88.9 cm). Museum of Fine Arts, Boston.

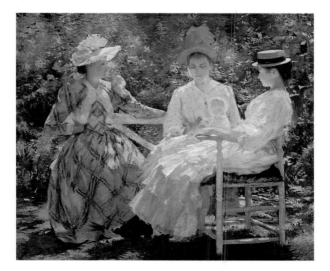

EDMUND TARBELL (1862–1938).
Three Sisters—A Study in June Sunlight, 1890. Oil on canvas,
35⅛ x 40⅛ in. (89.2 x 101.9 cm). Milwaukee Art Museum.

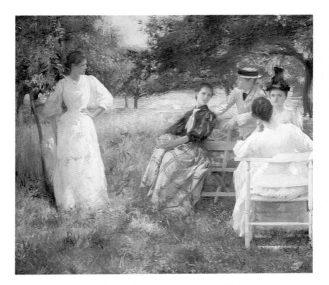

EDMUND TARBELL (1862–1938).
In the Orchard, 1891. Oil on canvas, 60½ x 65 in.
(153.7 x 165.1 cm). Herbert M. and Beverly Gelfand.

ROBERT VONNOH (1858–1933).
Poppies, 1888. Oil on canvas, 13 x 18 in. (33 x 45.7 cm).
Indianapolis Museum of Art.

ROBERT VONNOH (1858–1933).
Spring in France (Summer Landscape), 1890. Oil on canvas,
15 x 22 in. (38.1 x 55.9 cm). The Art Institute of Chicago.

ROBERT VONNOH (1858–1933).
Coquelicots (Poppies), "In Flanders Field," c. 1890.
Oil on canvas, 58 x 104 in. (147.3 x 264.2 cm).
The Butler Institute of American Art, Youngstown, Ohio.

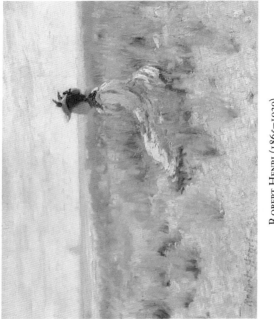

ROBERT HENRI (1865–1929).
Girl Seated by the Sea, 1893. Oil on canvas, 18 x 24 in. (45.7 x 61 cm). Mr. and Mrs. Raymond J. Horowitz.

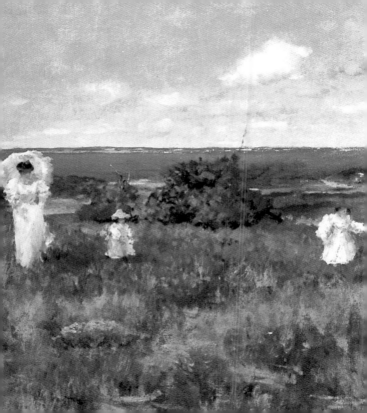

The Impressionist aesthetic was perhaps *the* major issue among American art writers in the decade after Durand-Ruel's 1886 exhibition. Until about 1889 it remained moderately controversial, partly because Impressionism was still considered a foreign phenomenon. As Impressionist-tinged work painted by Americans began to be seen in America, the controversy quickened. Vehement detractors such as Alfred Trumble and William Howe Downes denounced the American Impressionists as "imitators" and followers of "the purple mania." Supporters such as Cecilia Waern, however, wrote sympathetically about the French Impressionists, and Roger Riordan responded to the attacks by emphasizing both the growing universality of Impressionism and the individuality of the French and the American practitioners. The critics were not swayed, but the continued reaction against Impressionism by such distinguished writers attests to its growing dominance in American contemporary art.

Impressionism was also disseminated through the summer outdoor art schools that proliferated in the United States around 1890. While mid-century landscape

painters had also sought out desirable terrains, formalized outdoor teaching seems to have been initiated about 1889–90 by Impressionist-inspired Americans recently trained in Europe, many of whom had summered at the various outdoor colonies in France. John Twachtman taught an influential summer course at Newport, Rhode Island, and later at Cos Cob, Connecticut, along with J. Alden Weir; Theodore Robinson, with several others, held classes in upstate New York.

The most significant outdoor painting school was established by William Merritt Chase at Shinnecock, Long Island. Chase's own painting converged most closely with Impressionism during those fertile years when he was involved with summer outdoor teaching. Essentially an urban artist and a devoted realist, Chase adopted Impressionist techniques only when they were useful to him in realizing his perceptions of reality—as in the beautiful, broadly rendered sunlit landscapes he painted at Shinnecock. Besides twelve summers at the Shinnecock school, Chase also taught in Manhattan, Brooklyn, and Europe; ultimately he became the most important art teacher of his generation.

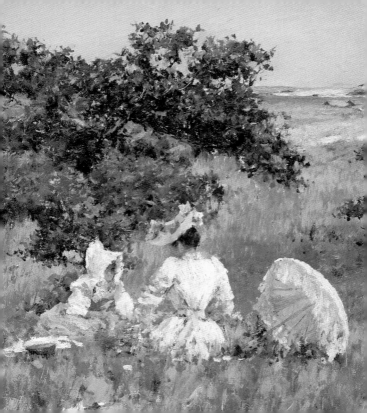

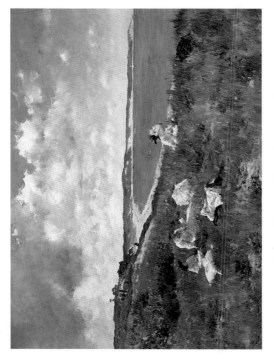

William Merritt Chase (1849–1916).
Idle Hours, 1894. Oil on canvas, 25½ x 35½ in.
(64.8 x 90.2 cm). Amon Carter Museum, Fort Worth.

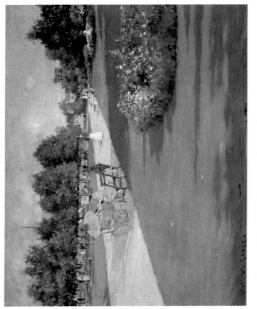

WILLIAM MERRITT CHASE (1849–1916).
Prospect Park, Brooklyn, n.d. Oil on canvas,
17⅞ x 22⅜ in. (44.2 x 56.9 cm).
Colby College Museum of Art, Waterville, Maine.

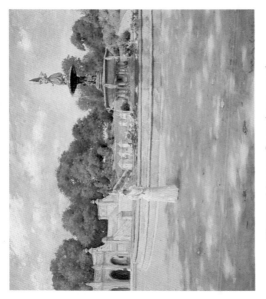

WILLIAM MERRITT CHASE (1849–1916).
An Early Stroll Through the Park, 1890.
Oil on canvas, 20⅜ x 24¼ in. (51.6 x 61.6 cm).
Montgomery Museum of Fine Arts, Montgomery, Alabama

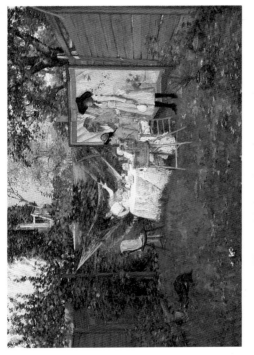

WILLIAM MERRITT CHASE (1849–1916).
The Open-Air Breakfast, c. 1888. Oil on canvas, 37⅜ x 56¾ in.
(95 x 144.1 cm). The Toledo Museum of Art, Toledo, Ohio.

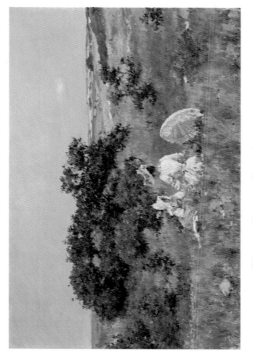

WILLIAM MERRITT CHASE (1849–1916).
The Fairy Tale, 1892. Oil on canvas, 16½ x 24½ in.
(41.9 x 62.2 cm). Mr. and Mrs. Raymond J. Horowitz.

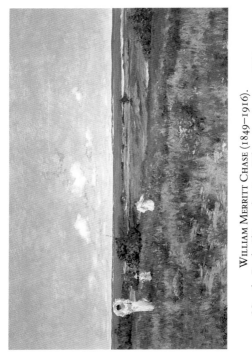

WILLIAM MERRITT CHASE (1849–1916).
Near the Beach, Shinnecock, 1895. Oil on canvas, 30 x 48⅛ in.
(76.2 x 122.2 cm). The Toledo Museum of Art, Toledo, Ohio.

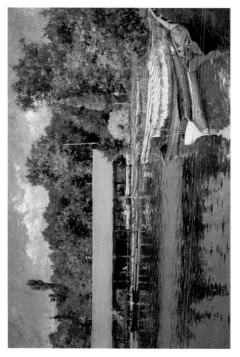

WILLIAM MERRITT CHASE (1849–1916).
Boat House, Prospect Park, c. 1897. Oil on panel, 10¼ x 16 in.
(26 x 40.6 cm). Margaret Newhouse.

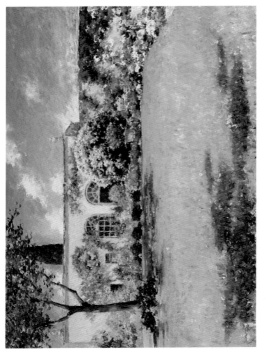

WILLIAM MERRITT CHASE (1849–1916).
The Orangerie, c. 1910. Oil on cradled panel, 23½ x 33 in.
(59.7 x 83.8 cm). Spanierman Gallery, New York.

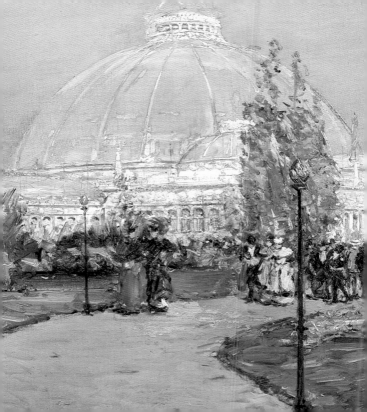

III.

THE YEARS OF TRIUMPH,

1893–1898

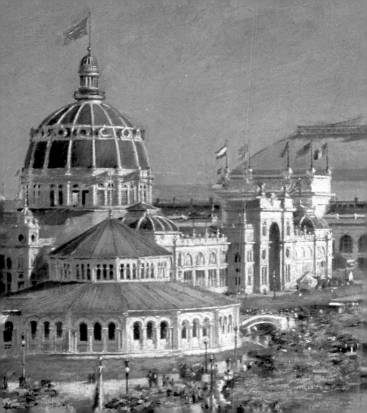

5.
THE WORLD'S
COLUMBIAN EXPOSITION
OF 1893

The major cultural event in America during the years of Impressionist development was the World's Columbian Exposition of 1893 in Chicago. Some significant triumphs of American Impressionism were on view, including two spectacular murals by Mary Cassatt and Mary Fairchild MacMonnies that decorated the Woman's Building. Important paintings by Frank Benson, Childe Hassam, Theodore Robinson, Edmund Tarbell, John Twachtman, and Robert Vonnoh were included in the main Art Gallery. Given the large size of the American exhibition, however, there were comparatively few totally Impressionist pictures.

Impressionism was virtually absent from the official French display, although there were paintings by Edgar Degas, Edouard Manet, Claude Monet, Camille Pissarro, Auguste Renoir, and Alfred Sisley in the unofficial exhibition of foreign works from private American collections. Yet even if the Impressionist paintings were a minority, the exposition was a vindication of Impressionism

because the new aesthetic of light and color seemed to dominate, to "shine out" in every gallery.

Impressionism found its most enthusiastic champion in the midwestern writer Hamlin Garland. A founder of the Central Art Association in Chicago, Garland was searching for an Americanized response to Impressionism. Even though he promoted the Impressionists, especially Tarbell and Benson, he deplored the lack of American content in their work. In 1894 Garland discovered—and named—the Hoosier School, the first regional group to work in the new aesthetic.

The Hoosier group—which included John Ottis Adams, William Forsyth, Theodore Steele, and later Otto Stark—worked in Indiana, where they painted colorful, light-filled landscapes of the local countryside. Steele and Forsyth exhibited at the 1893 Chicago Exposition, an event that signaled the emergence of the Midwest as a significant cultural force. Garland and other critics praised the painters of the Hoosier School both for their indigenous subject matter and their modified Impressionism; their paintings were deemed to be not as "wild" as some by their East Coast and French contemporaries. After the Columbian Exposition, exhibitions of Impressionism were seen from Saint Louis to San Francisco, and through these exhibitions the Hoosier painters gained national attention.

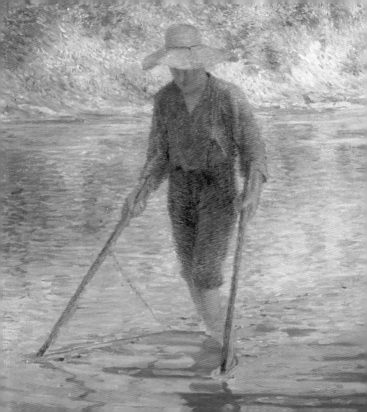

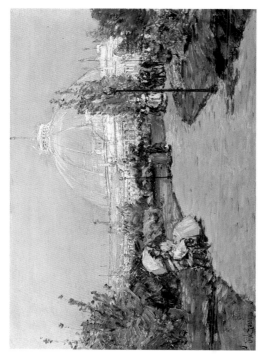

CHILDE HASSAM (1859–1935).
Crystal Palace, Chicago Exposition, 1893. Oil on canvas,
18 x 26 in. (45.7 x 66 cm). Mrs. Norman B. Woolworth.

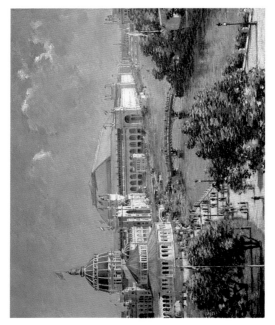

THEODORE ROBINSON (1852–1896).
Chicago Columbian Exposition, 1894. Oil on canvas, 25 x 30 in.
(63.5 x 76.2 cm). Private collection.

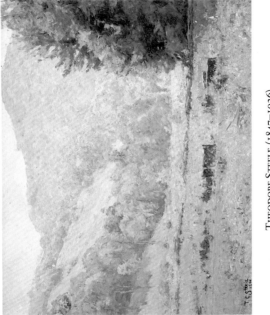

THEODORE STEELE (1847–1926).
Whitewater Valley, 1899. Oil on canvas, 21⅞ x 29 in. (55.6 x 73.7 cm).
Ball State University Art Gallery, Muncie, Indiana.

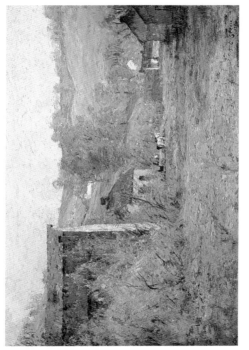

THEODORE STEELE (1847–1926).
The Old Mills, 1903. Oil on canvas, 30 x 45 in.
(76.2 x 114.3 cm). Mr. and Mrs. Clarence W. Long.

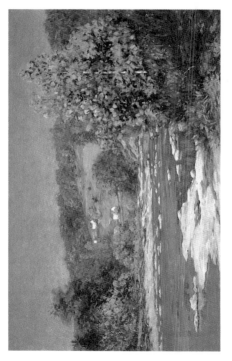

JOHN OTTIS ADAMS (1851–1927).
Blue and Gold, 1904. Oil on canvas, 18 x 28 in.
(45.7 x 71.1 cm). Private collection.

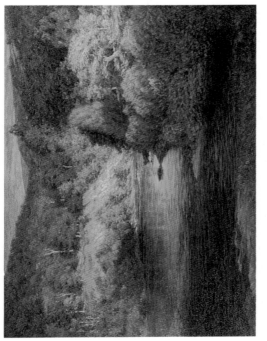

John Ottis Adams (1851–1927).
The Ebbing of Day (The Bank), 1902. Oil on canvas, 34⅛ x 47⅞ in.
(86.6 x 121.7 cm). Ball State University Art Gallery, Muncie, Indiana.

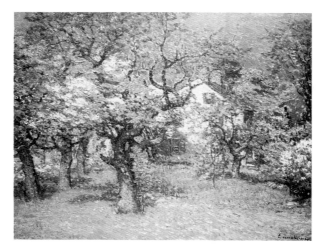

JOHN J. ENNEKING (1841–1916).
Through the Orchard, c. 1895. Oil on canvas, 24 x 36 in.
(61 x 91.4 cm). Private collection.

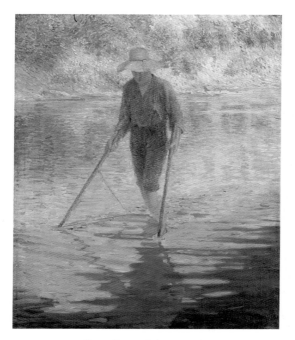

OTTO STARK (1859–1926).
The Seiner, 1900. Oil on canvas, 27 x 22 in. (68.6 x 55.9 cm).
Mr. and Mrs. Clarence W. Long.

THE MASTER IMPRESSIONISTS

As Impressionism became increasingly popular, accessible, and well received during the mid-1890s, each major Impressionist established an individual rapport with the style. Toward the end of his career Theodore Robinson, painting landscapes in rural New York, began to doubt that he could reconcile the colorism and painterliness of Impressionism with traditional aspects of design. In 1894 he joined John Twachtman at Cos Cob, Connecticut, where he painted a series of coastal pictures that are brilliant in tonality but abstract in design. Despite his irresolute search to fuse painterliness and structure, Robinson contributed significantly to the development of Impressionism in America.

Childe Hassam continued to consolidate his position as one of the foremost American Impressionists. His reputation was established as a painter of the city in all seasons and moods. Hassam never renounced the chromaticism or brilliant brushwork of Impressionism, but he was at times concerned with reinforcing structure in his compositions. An 1896 exhibition in New York featured over two hundred examples of his impressively

diverse art—a magnitude of work unprecedented for a living artist.

Twachtman painted numerous scenes of his house, property, and garden in Connecticut. Though he seems never to have met Monet, Twachtman shared the French artist's devotion to depicting his personal surroundings at different seasons. Twachtman had a far more emotional response to the landscape than Monet, however, and his unorthodox Impressionist style emphasized simple composition and an abstract sense of design. These elements, coupled with the evocativeness of his quiet winter scenes, suggest the influence of the Orient. By the early 1890s Twachtman, Robinson, and J. Alden Weir had all become enthusiastic students of Japanese art.

Weir embraced Impressionism later than many of his colleagues but in an equally personal way. His evolving commitment to Impressionism can be seen in his series of paintings of the thread factories in Willimantic, Connecticut. Perhaps influenced by his friend Robinson, Weir began experimenting with freer brushwork and a broader color range. His most famous landscape, *The Red Bridge* (opposite and page 151), pays homage to Japanese aesthetics, employing a high horizon, assertive geometry, and dominant diagonals.

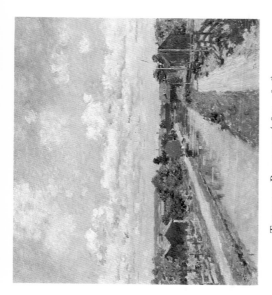

THEODORE ROBINSON (1852–1896).
Port Ben, Delaware and Hudson Canal, 1893. Oil on canvas, 28¼ x 32¼ in.
(71.8 x 81.9 cm). Pennsylvania Academy of
the Fine Arts, Philadelphia.

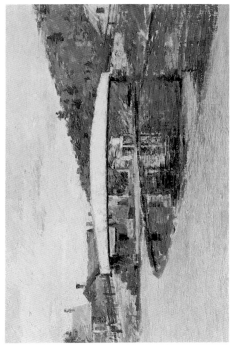

THEODORE ROBINSON (1852–1896).
The White Bridge, 1893. Oil on canvas, 15 x 22 in.
(38.1 x 55.9 cm). Mr. and Mrs. Ralph Spencer.

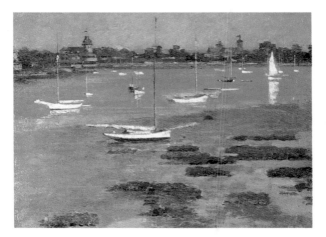

THEODORE ROBINSON (1852–1896).
Low Tide, Riverside Yacht Club, c. 1894. Oil on canvas, 18 x 24 in.
(45.7 x 61 cm). Mr. and Mrs. Raymond J. Horowitz.

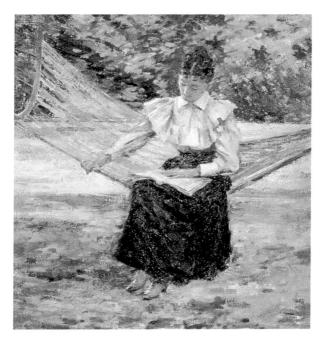

THEODORE ROBINSON (1852–1896).
Girl in a Hammock, 1894. Oil on canvas, 18 x 16⅝ in.
(45.7 x 42.2 cm). Mr. Stephen Rubin.

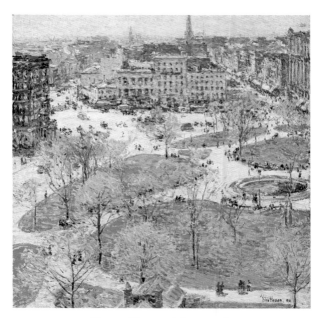

CHILDE HASSAM (1859–1935).
Union Square in Spring, 1896. Oil on canvas,
21½ x 21 in. (54.6 x 53.3 cm).
Smith College Museum of Art, Northampton, Massachusetts.

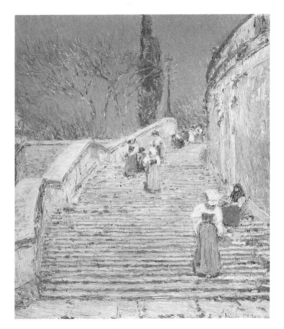

CHILDE HASSAM (1859–1935).
Piazza di Spagna, Rome, 1897. Oil on canvas,
29¼ x 23 in. (74.3 x 58.4 cm).
The Newark Museum, Newark, New Jersey.

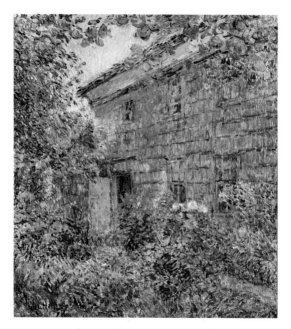

CHILDE HASSAM (1859–1935).
Old House and Garden, East Hampton, Long Island, 1898.
Oil on canvas, 24⅛ x 20 in. (61.2 x 50.8 cm).
Henry Art Gallery, University of Washington, Seattle.

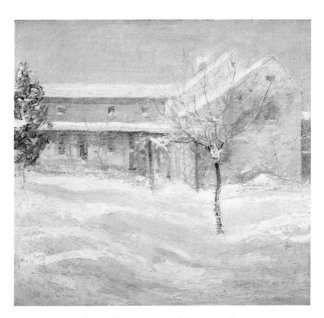

JOHN TWACHTMAN (1853–1902).
Old Holley House, 1890s. Oil on canvas, 25⅛ x 25⅛ in.
(63.8 x 63.8 cm). Cincinnati Art Museum.

143

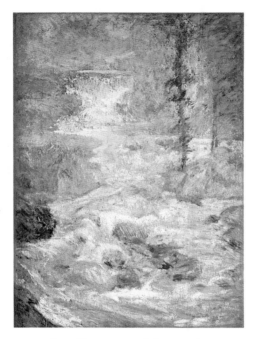

JOHN TWACHTMAN (1853–1902).
The Rainbow's Source, 1890s. Oil on canvas, 34⅛ x 24½ in.
(86.6 x 62.2 cm). The Saint Louis Art Museum.

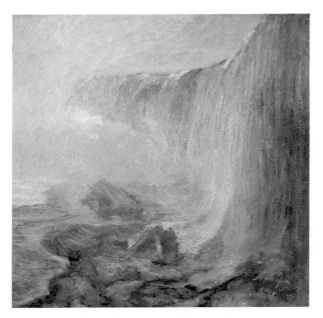

JOHN TWACHTMAN (1853–1902).
Niagara Falls, c. 1894. Oil on canvas, 30 x 30 in.
(76.2 x 76.2 cm). Mr. and Mrs. Raymond J. Horowitz.

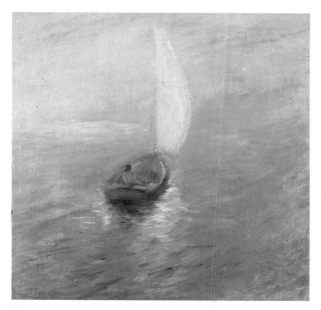

JOHN TWACHTMAN (1853–1902).
Sailing in the Mist, c. 1895. Oil on canvas,
30½ x 30½ in. (77.5 x 77.5 cm).
Pennsylvania Academy of the Fine Arts, Philadelphia.

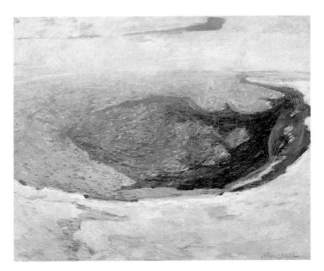

JOHN TWACHTMAN (1853–1902).
Emerald Pool, c. 1895. Oil on canvas,
25¼ x 30¼ in. (64.1 x 76.8 cm).
Wadsworth Atheneum, Hartford, Connecticut.

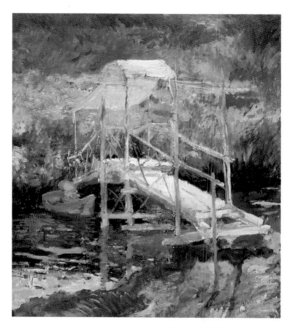

JOHN TWACHTMAN (1853–1902).
White Bridge, c. 1900. Oil on canvas,
30 x 25 in. (76.2 x 63.5 cm).
Memorial Gallery of the University of Rochester.

J. ALDEN WEIR (1852–1919).
The Laundry, Branchville, c. 1894. Oil on canvas,
30⅛ x 25¼ in. (76.5 x 64.1 cm). Private collection.

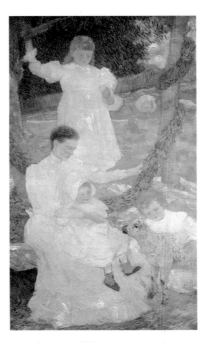

J. ALDEN WEIR (1852–1919).
In the Dooryard, probably 1894. Oil on canvas, 80⅛ x 47⅛ in.
(203.5 x 119.6 cm). Charles Burlingham, Jr.

J. ALDEN WEIR (1852–1919).
The Red Bridge, 1895. Oil on canvas, 24¼ x 33¾ in. (61.6 x 85.7 cm).
The Metropolitan Museum of Art, New York.

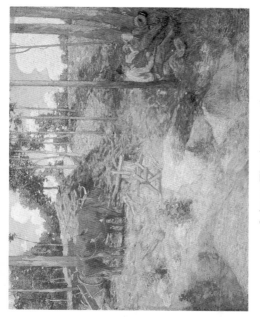

J. Alden Weir (1852–1919).
Midday Rest in New England, 1897. Oil on canvas,
40 x 50½ in. (101.6 x 128.3 cm).
Pennsylvania Academy of the Fine Arts, Philadelphia.

J. ALDEN WEIR (1852–1919).
Factory Village, 1897. Oil on canvas, 29 x 38 in.
(73.7 x 96.5 cm). Cora Weir Burlingham.

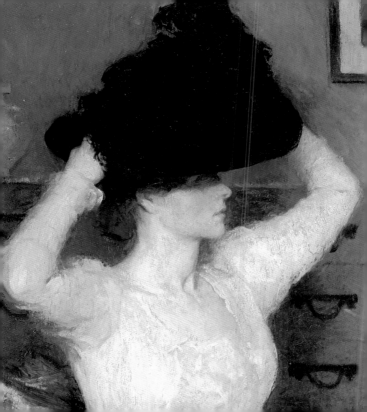

IV.

THE IMPRESSIONIST ESTABLISHMENT,

1898–1915

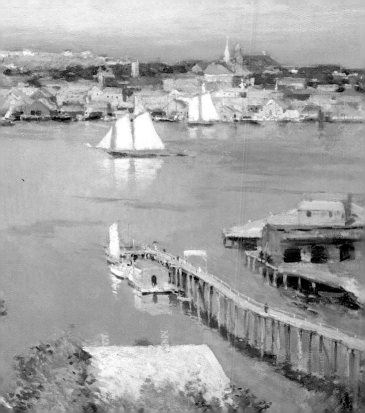

THE TEN AMERICAN PAINTERS

The Ten American Painters was a loosely knit organization that came to be regarded as a kind of academy of American Impressionism. Established in New York in 1898, it comprised Frank Benson, Joseph DeCamp, Thomas Wilmer Dewing, Childe Hassam, Willard Metcalf, Robert Reid, Edward Simmons, Edmund Tarbell, John Twachtman, and J. Alden Weir. After Twachtman died in 1902, his place was taken by William Merritt Chase.

The primary motivation for the Ten was not to provide a safe harbor for Impressionism; rather, it was established because of growing dissatisfaction with the dominant art organizations, especially the Society of American Artists. Disturbed by the great disparity in quality, the vast number of works, and the tremendous variety of styles in the Society exhibitions, these artists united to mount their own exhibitions where their paintings could be seen comfortably, harmoniously, and selectively.

The Ten lasted for twenty years, and their exhibitions were generally well received until about 1917. During the prior decade Benson, Hassam, Tarbell,

Twachtman, and Weir—the most established Impressionists—had exhibited a surprising, even radical diversity of work.

Joseph DeCamp's best-known paintings of the 1890s are poetic renditions of the nude, painted in a darker, more academic style than that of the Impressionists. DeCamp and particularly Metcalf became far more integrated within the American Impressionist camp in the decades after the Ten was formed, undoubtedly stimulated by that association.

Thomas Wilmer Dewing and Edward Simmons always remained outside the movement. Dewing was an adherent of Tonalism; in fact he was *the* Tonalist figure painter. Simmons's style was even less Impressionist; he painted powerful peasant figures and some outstanding marine paintings, as well as celebrated murals.

Robert Reid was the member of the Ten who emerged most clearly as an Impressionist. His very distinctive paintings tended to be highly decorative—modishly gowned and coiffured female figures, often with floral attributes, painted in broad, ribbonlike strokes of bright color and with a vivid sense of motion. Their essential decorativeness was underscored in his manipulation of forms, color, and space. Reid later became involved with mural painting and portraiture, creating "portrait impressions" in the vivacious, sinuous brush strokes of his earlier Impressionist days.

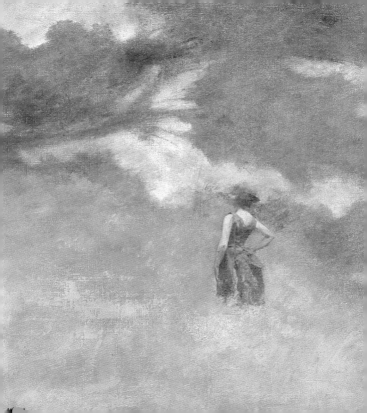

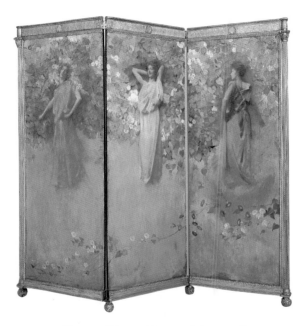

THOMAS WILMER DEWING (1851–1938).
Morning Glories, n.d. Oil on canvas on wood,
64½ x 72 in. (163.8 x 182.9 cm), overall.
Museum of Art, Carnegie Institute, Pittsburgh.

THOMAS WILMER DEWING (1851–1938).
Recitation, 1891. Oil on canvas, 30 x 55 in. (76.2 x 139.7 cm).
The Detroit Institute of Arts.

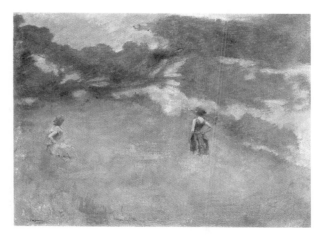

THOMAS WILMER DEWING (1851–1938).
The Hermit Thrush, c. 1893. Oil on canvas, 34¾ x 46⅛ in.
(88.3 x 117.1 cm). National Museum of American Art,
Smithsonian Institution, Washington, D.C.

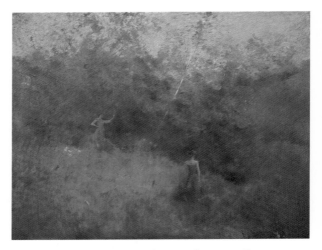

THOMAS WILMER DEWING (1851–1938).
The White Birch, c. 1896–99.
Oil on canvas, 42 x 53⅞ in. (106.7 x 136.9 cm).
Washington University Gallery of Art, Saint Louis.

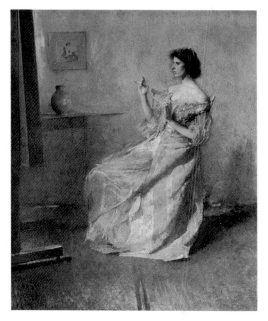

THOMAS WILMER DEWING (1851–1938).
The Necklace, 1907. Oil on wood, 20 x 15¾ in. (50.8 x 40 cm).
National Museum of American Art,
Smithsonian Institution, Washington, D.C.

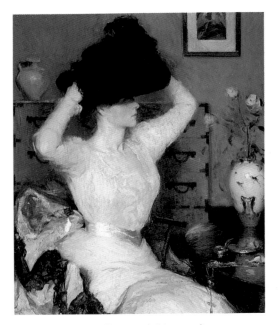

FRANK BENSON (1862–1951).
Lady Trying on a Hat, 1904. Oil on canvas,
40¼ x 32 in. (102.2 x 81.3 cm). Museum of Art,
Rhode Island School of Design, Providence.

EDWARD SIMMONS (1852–1931).
A River in Winter, n.d. Oil on canvas, 14 x 22¼ in.
(35.6 x 56.5 cm). Graham Williford.

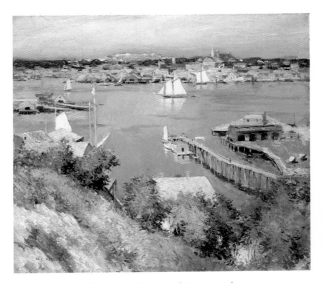

WILLARD METCALF (1858–1925).
Gloucester Harbor, 1895. Oil on canvas, 26 x 28¾ in.
(66 x 73 cm). Mead Art Museum, Amherst College,
Amherst, Massachusetts.

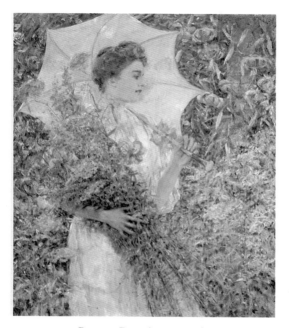

ROBERT REID (1862–1929).
The White Parasol, c. 1900. Oil on canvas, 36 x 30 in.
(91.4 x 76.2 cm). National Museum of American Art,
Smithsonian Institution, Washington, D.C.

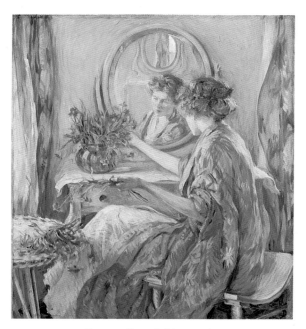

ROBERT REID (1862–1929).
The Violet Kimono, 1910. Oil on canvas, 29 x 26¾ in.
(73.7 x 68 cm). National Museum of American Art,
Smithsonian Institution, Washington, D.C.

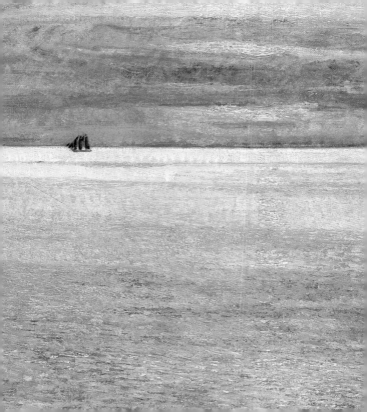

THE MASTER IMPRESSIONISTS

For Childe Hassam, the decades after the formation of the Ten were productive years in which he explored a variety of themes. His continued involvement with the urban scene yielded beautiful cityscapes of New York, Paris, and London. He also painted panoramic views of New England towns that are remarkable for their scintillating Impressionist color and brushwork secured by a strong sense of geometry. These optimistic pictures are affirmations of Hassam's New England heritage, as are his depictions of the Congregational Church at Old Lyme, Connecticut.

Hassam's 1908 Oregon landscapes display a new sense of decorative pattern and an almost antinaturalistic organization of forms—trends that he carried to a brilliant extreme in his colorful, nearly abstract *Sunset at Sea* (opposite and page 174). His inventive, compositionally complex pictures of women in interiors display geometric structure and decorative elements while emphasizing Hassam's continuing Impressionist interest in light.

Painting his final canvases at Gloucester, John Twachtman reverted, in a sense, to the darker manner he

had learned during his student days in Munich. These paintings underscore the structural planes and outlines of buildings, and he reintroduced the black he had once banished. Twachtman did not completely return to an earlier aesthetic, however; his sophisticated sense of design remained a part of his painting, as did his predilection for square canvases.

J. Alden Weir's large outdoor paintings of his daughters, such as *The Donkey Ride* (page 176), exhibit a return to a more academic rendering, but the compositions are considerably flattened. The treatment of light and brushwork in these pictures creates almost tapestry-like effects, suggesting aspects of later Impressionism and Post-Impressionism.

Willard Metcalf came to prominence after 1903, when he turned anew to Impressionism. His sparkling Impressionist landscapes painted at Old Lyme, Connecticut, established him as a master of the genre. He developed as a painter of seasonal landscapes and, like Twachtman, was especially drawn to winter scenes. His fascinating *White Veil* (page 181) combines the broken brushwork of Impressionism with a limited, Tonalist color range. Until his death in 1925 Metcalf continued to paint panoramic, richly colored New England landscapes, becoming known as "the poet laureate of the New England hills" and the truly *American* Impressionist.

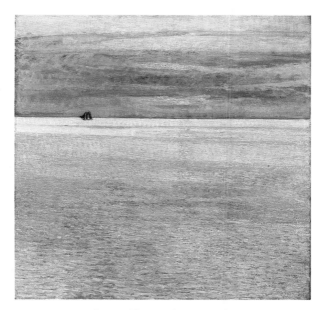

CHILDE HASSAM (1859–1935).
Sunset at Sea, 1911. Oil on burlap, 34 x 34 in.
(86.4 x 86.4 cm). Rose Art Gallery, Brandeis University,
Waltham, Massachusetts.

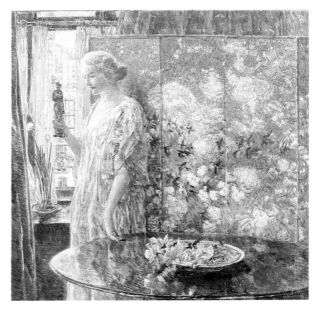

CHILDE HASSAM (1859–1935).
Tanagra, 1918. Oil on canvas, 58¾ x 58¾ in.
(149.2 x 149.2 cm). National Museum of American Art,
Smithsonian Institution, Washington, D.C.

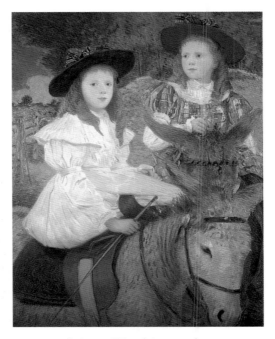

J. ALDEN WEIR (1852–1919).
The Donkey Ride, 1899–1900. Oil on canvas, 49 x 38 in.
(124.5 x 96.5 cm). Cora Weir Burlingham.

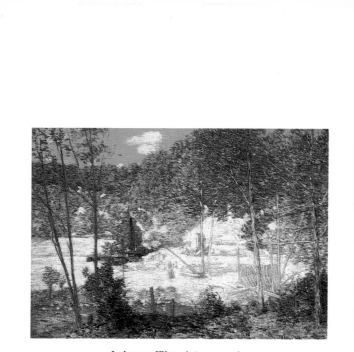

J. ALDEN WEIR (1852–1919).
Building a Dam, Shetucket, 1908. Oil on canvas, 31¼ x 40¼ in.
(79.4 x 102.2 cm). The Cleveland Museum of Art.

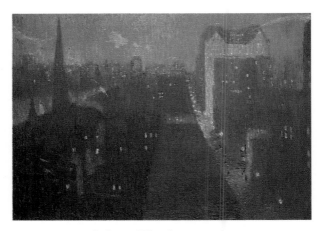

J. ALDEN WEIR (1852–1919).
The Plaza: Nocturne, 1911. Oil on canvas, 29 x 39½ in.
(73.7 x 100.3 cm). Hirshhorn Museum and Sculpture Garden,
Smithsonian Institution, Washington, D.C.

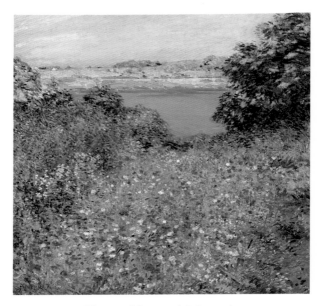

WILLARD METCALF (1858–1925).
The Poppy Garden, 1905. Oil on canvas, 24 x 24 in.
(61 x 61 cm). Private collection.

WILLARD METCALF (1858–1925).
May Night, 1906. Oil on canvas, 39½ x 36⅜ in.
(100.3 x 92.5 cm). The Corcoran Gallery of Art,
Washington, D.C.

WILLARD METCALF (1858–1925).
White Veil, 1909. Oil on canvas, 36 x 36 in. (91.4 x 91.4 cm).
Detroit Institute of Arts.

WILLARD METCALF (1858–1925).
Icebound, 1909. Oil on canvas, 29 x 26⅛ in. (73.7 x 66.3 cm).
The Art Institute of Chicago.

WILLARD METCALF (1858–1925).
Early Spring Afternoon, Central Park, 1911. Oil on canvas,
36⅛ x 36 in. (91.7 x 91.4 cm). The Brooklyn Museum.

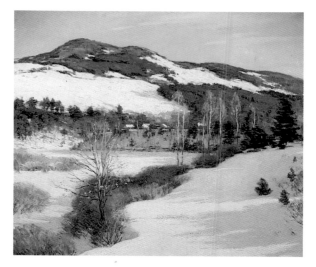

WILLARD METCALF (1858–1925).
Cornish Hills, 1911. Oil on canvas, 35 x 40 in.
(88.9 x 101.6 cm). Thomas Barwick.

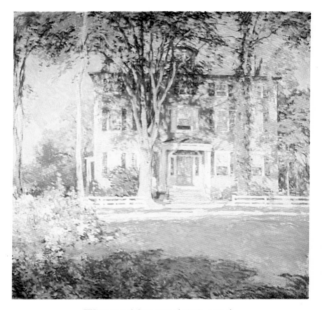

WILLARD METCALF (1858–1925).
Captain Lord House, Kennebunkport, Maine, c. 1920.
Oil on canvas, 36 x 36 in. (91.4 x 91.4 cm). Lyme Historical
Society, Florence Griswold Museum, Old Lyme, Connecticut.

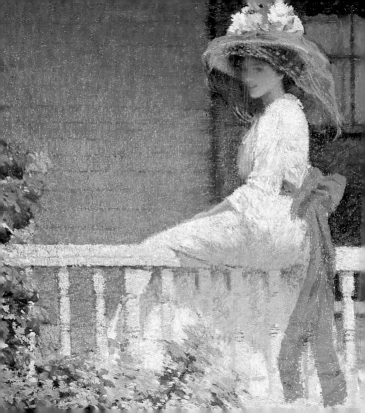

9.
REGIONAL SCHOOLS

By the beginning of this century regional "schools" of art arose for the first time, and they were often Impressionist dominated. In addition to the Hoosier School in Indiana, the Boston School and the school in Old Lyme, Connecticut, are especially significant for the quality of their work and the importance of their artists.

The Boston School, under the leadership of Edmund Tarbell, was dominated by figure painting. Influenced by the work of the Dutch artist Jan Vermeer, Tarbell and his followers—especially Joseph DeCamp, Philip Leslie Hale, and William Paxton—turned to a subtler Tonalism in the 1890s, painting polished portraits and elegant, softly lit interior views of contemplative young women surrounded by beautiful objects. At the same time Frank Benson was painting outdoor scenes of women and children that emphasize blazing sunlight, bright colors, and pure white.

The Old Lyme colony was originally influenced by the Tonal landscapist Henry Ward Ranger. Childe Hassam arrived in 1903, shifting the Old Lyme aesthetic toward Impressionism. Willard Metcalf and many others,

including Edward Rook and Guy Wiggins, came to depict the town, its swirling waters, and its flowering laurel in bright, Impressionist views. The Art Students League of New York held summer classes at Old Lyme until their popularity prompted a move to Woodstock, New York. At nearby Cragsmoor, New York, Charles Courtney Curran and Helen Turner painted radiant pictures of women in sunlight.

The major "school" of Impressionism in Pennsylvania flourished not in Philadelphia but in the area around New Hope. Its central figure was Edward Redfield, whose large, vigorous, often dashingly painted landscapes became the hallmark of Pennsylvania Impressionism. Another New Hope artist, Daniel Garber, explored the colorful decorativeness of Post-Impressionism in his sunlit landscapes and figure paintings.

Although the South did not embrace Impressionism, the style did become popular in the Midwest, due largely to the attention focused on Impressionist works at the 1893 Columbian Exposition and to the reputation of the Hoosier School. Cincinnati spawned a number of exceptional Impressionists, including John Twachtman and Edward Potthast, who is known for his brilliantly colored New York beach scenes. The Brown County School in Indiana, dominated by the Hoosier artist Theodore Steele, attracted many landscapists from Chicago, including Carl Krafft, who founded the Society of

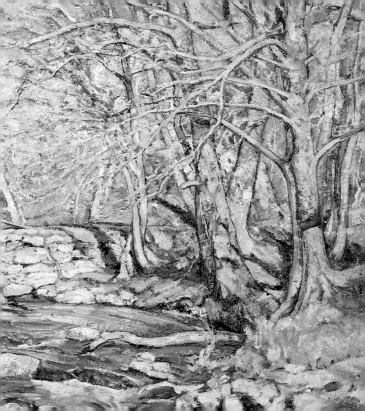

Ozark Painters in Missouri. Two other Chicago land-scapists, William Wendt and Alson Clark, eventually settled near Los Angeles and transmitted the Impressionist aesthetic to Southern California.

In California, Impressionism spread first to San Francisco, where French Impressionist paintings were shown in 1894. In 1903 the San Franciscan Joseph Raphael went to Europe, where he developed a highly original Impressionist-derived style. He exhibited at the 1915 Panama-Pacific Exposition, along with Hassam, Tarbell, J. Alden Weir, and others. The first full-scale introduction of the movement to this area, it was a revelation to local artists such as Selden Gile. Some of the paintings then traveled to Los Angeles, where Impressionism was slowly developing. Nearby Laguna Beach attracted a number of Impressionist artists, and in San Diego, Maurice Braun began producing some of the most brilliant and meditative California landscapes of his generation.

The most active western art colonies to emerge outside of California were in New Mexico, at Santa Fe and especially Taos. The strong color and light that characterize most Taos paintings are especially intense in the works of Impressionist-related artists such as Ernest Blumenschein.

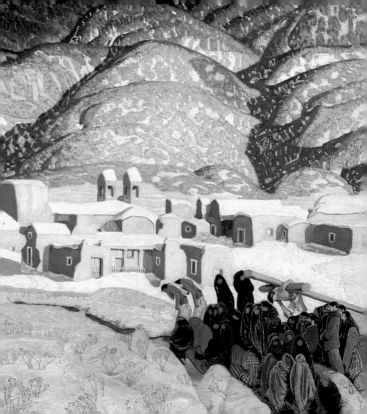

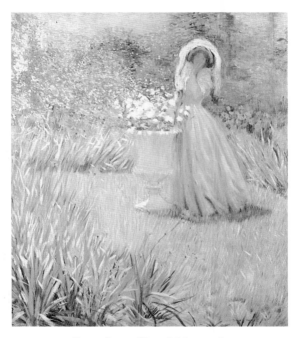

PHILIP LESLIE HALE (1865–1931).
Walking Through the Fields (In the Garden), mid-1890s. Oil on
canvas, 30 x 25 in. (76.2 x 63.5 cm). Vose Galleries of Boston.

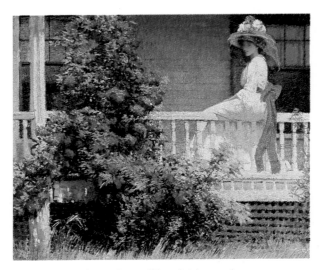

PHILIP LESLIE HALE (1865–1931).
The Crimson Rambler, n.d.
Oil on canvas, 25 x 30 in. (63.5 x 76.2 cm).
Pennsylvania Academy of the Fine Arts, Philadelphia.

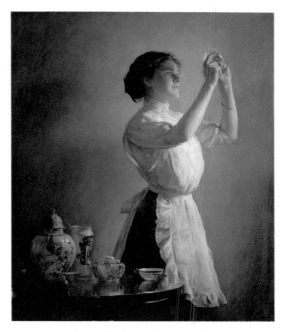

JOSEPH DeCAMP (1858–1923).
The Blue Cup, 1909. Oil on canvas, 50½ x 41½ in.
(128.3 x 105.4 cm). Museum of Fine Arts, Boston.

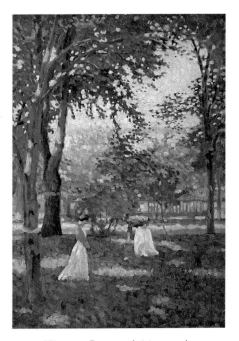

WILLIAM PAXTON (1869–1941).
The Croquet Players, c. 1898. Oil on canvas, 32 x 21 in.
(81.3 x 53.3 cm). Private collection, Boston.

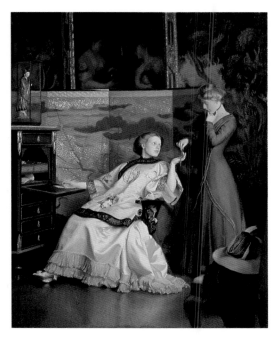

WILLIAM PAXTON (1869–1941).
The New Necklace, 1910. Oil on canvas, 35½ x 28½ in.
(90.2 x 72.4 cm). Museum of Fine Arts, Boston.

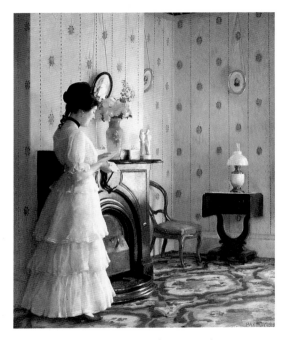

WILLIAM PAXTON (1869–1941).
The Front Parlor, 1913. Oil on canvas, 27 x 22⅛ in.
(68.6 x 56.1 cm). The Saint Louis Art Museum.

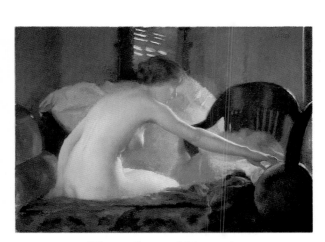

WILLIAM PAXTON (1869–1941).
Nude, 1915. Oil on canvas, 24 x 33 in. (61 x 83.8 cm).
Museum of Fine Arts, Boston.

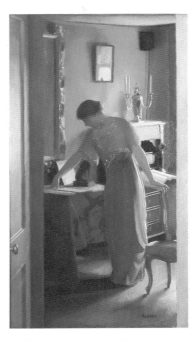

WILLIAM PAXTON (1869–1941).
The Other Room, 1916. Oil on canvas, 31½ x 17½ in.
(80 x 44.5 cm). El Paso Museum of Art, El Paso, Texas.

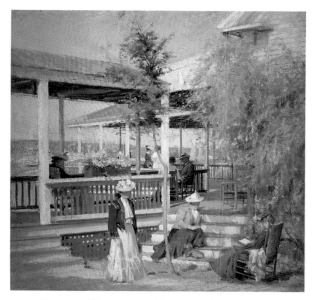

Edward Wilbur Dean Hamilton (1864–1943).
Summer at Campobello, New Brunswick, c. 1890–1900.
Oil on academy board, 28 x 28 in. (71.1 x 71.1 cm).
Museum of Fine Arts, Boston.

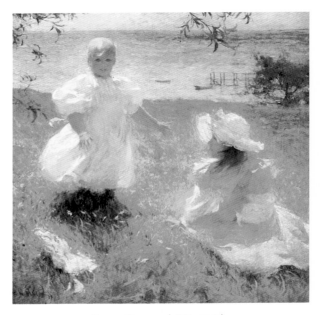

Frank Benson (1862–1951).
The Sisters, 1899. Oil on canvas,
40 x 39½ in.(101.6 x 100.3 cm).
IBM Corporation, Armonk, New York.

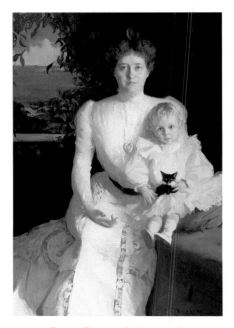

FRANK BENSON (1862–1951).
Mrs. Benjamin Thaw and Her Son, Alexander Blair Thaw III,
1900. Oil on canvas, 60 x 39½ in. (152.4 x 100.3 cm).
Berry-Hill Galleries, New York.

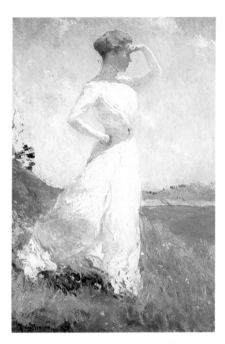

FRANK BENSON (1862–1951).
Sunlight, 1909. Oil on canvas, 32¼ x 20 in. (81.9 x 50.8 cm).
Indianapolis Museum of Art.

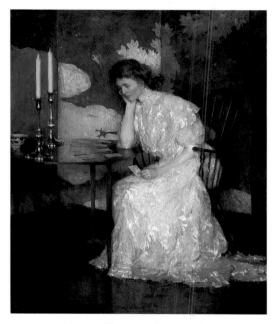

Frank Benson (1862–1951).
Girl Playing Solitaire, 1909. Oil on canvas, 50½ x 40½ in.
(128.3 x 102.9 cm). Worcester Art Museum,
Worcester, Massachusetts.

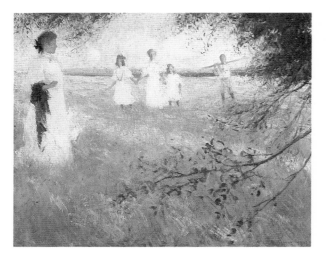

FRANK BENSON (1862–1951).
Evening Light, 1908. Oil on canvas, 25¼ x 30½ in.
(64.1 x 77.5 cm). Cincinnati Art Museum.

LEWIS MEAKIN (1850–1917).
Salt Marsh, Cape Ann, 1892. Oil on canvas, 21¼ x 33⅛ in.
(54 x 84.1 cm). Cincinnati Art Museum.

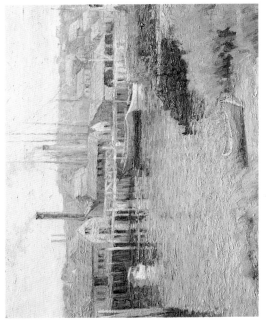

HARRIET LUMIS (1870–1953).
Morning in the Harbor, c. 1918. Oil on canvas, 18 x 22 in.
(45.7 x 55.9 cm). Location unknown.

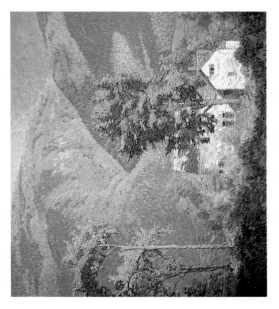

GEORGE NOYES (1864–1954).
The Gorge, 1910. Oil on canvas, 30½ x 34¼ in. (77.5 x 87 cm).
Furman Collection.

WALTER CLARK (1848–1917).
Noank, 1900. Oil on canvas, 20 x 30 in. (50.8 x 76.2 cm).
A. Everette James, Jr., J.D., M.D., and family.

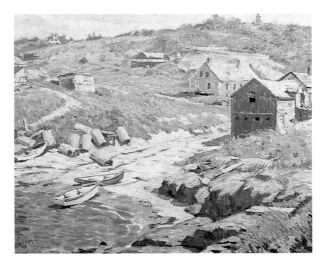

CHARLES EBERT (1873–1959).
Monhegan Cove, n.d. Oil on canvas, 25 x 30 in. (63.5 x 76.2 cm).
Lyman Allyn Museum, New London, Connecticut.

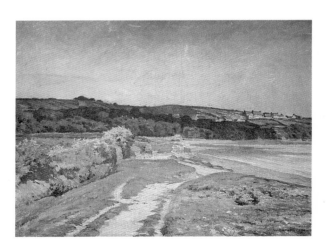

WALTER GRIFFIN (1861–1935).
Brittany Coast, 1894. Oil on canvas, 19¼ x 25½ in.
(48.9 x 64.8 cm). Vose Galleries of Boston.

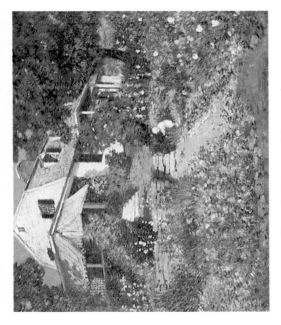

CLARK G. VOORHEES (1871–1933).
My Garden, c. 1914. Oil on canvas, 28¾ x 36 in.
(73 x 91.4 cm). Michael Voorhees.

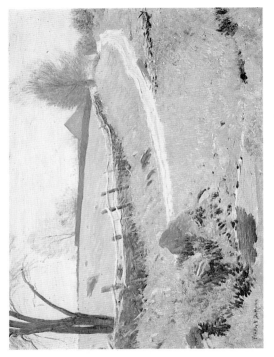

FRANK DUMOND (1865–1951).
Autumn, Grassy Hill, n.d. Oil on canvas, 10 x 14 in.
(25.4 x 35.6 cm). Nelson C. White.

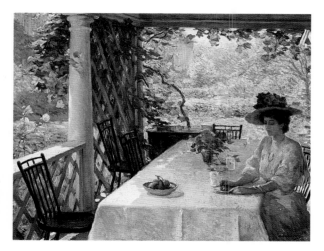

WILLIAM CHADWICK (1879–1962).
On the Porch, c. 1908. Oil on canvas,
24 x 30 in. (61 x 76.2 cm). Lyme Historical Society,
Florence Griswold Museum, Old Lyme, Connecticut.

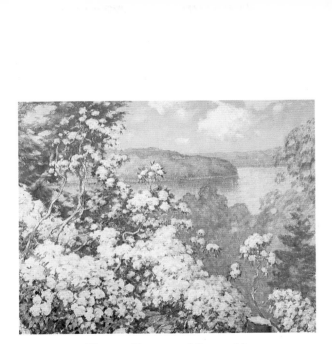

WILLIAM CHADWICK (1879–1962).
Hamburg Cove, 1923. Oil on canvas,
36¼ x 40⅛ in. (92.1 x 101.9 cm). The Museum at the
Holyoke Public Library, Holyoke, Massachusetts.

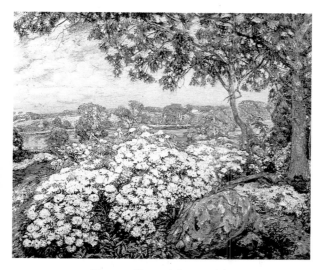

EDWARD ROOK (1870–1960).
Laurel, c. 1905–10. Oil on canvas, 40¼ x 50⅜ in.
(102.2 x 128 cm). Private collection.

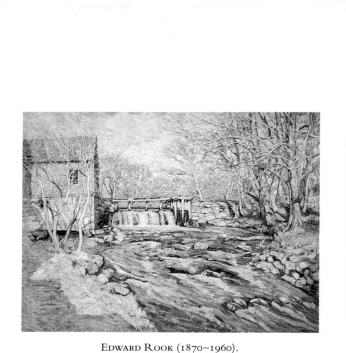

EDWARD ROOK (1870–1960).
Bradbury's Mill, Swirling Waters, c. 1917. Oil on canvas,
30¼ x 38⅝ in. (76.8 x 98.3 cm). Lyme Historical Society,
Florence Griswold Museum, Old Lyme, Connecticut.

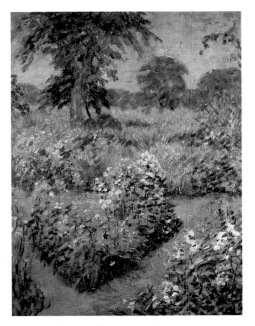

GEORGE B. BURR (1876–1939).
Old Lyme Garden, n.d. Oil on canvas,
12 x 9 in. (30.5 x 22.9 cm). Lyme Historical Society,
Florence Griswold Museum, Old Lyme, Connecticut.

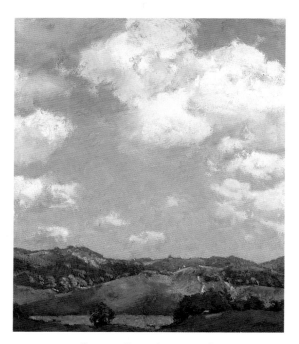

CHARLES DAVIS (1856–1933).
Sky, n.d. Oil on canvas, 36 x 30 in. (91.4 x 76.2 cm).
Lyman Allyn Museum, New London, Connecticut.

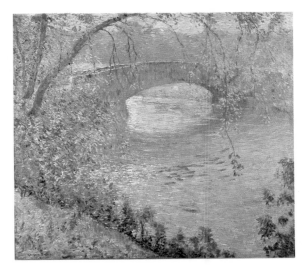

GREGORY SMITH (n.d.).
The Bow Bridge, 1912–15. Oil on canvas, 36 x 40 in.
(91.4 x 101.6 cm). Gregory Smith.

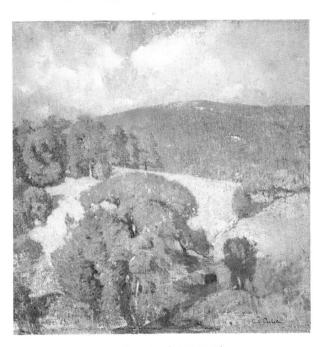

EMIL CARLSEN (1853–1932).
Connecticut Hillside, c. 1920. Oil on canvas, 29¼ x 27⅜ in.
(74.3 x 69.6 cm). The Art Institute of Chicago.

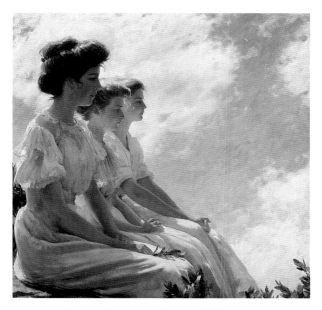

CHARLES COURTNEY CURRAN (1861–1942).
On the Heights, 1909. Oil on canvas, 30⅛ x 30⅛ in.
(76.5 x 76.5 cm). The Brooklyn Museum.

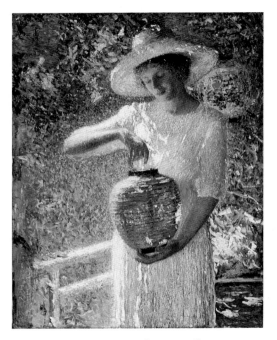

HELEN TURNER (1858–1958).
Girl with Lantern, 1914. Oil on canvas, 44 x 34 in.
(111.8 x 86.4 cm). Private collection.

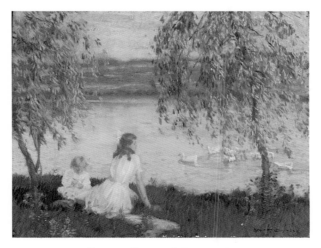

EDWARD DUFNER (1872–1957).
Summer Days, n.d.
Oil on board, 16 x 19¾ in. (40.6 x 50.2 cm).
The Parthenon, Nashville.

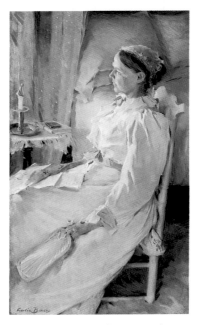

CECILIA BEAUX (1863–1942).
New England Woman (Mrs. Jedediah H. Richards), 1895.
Oil on canvas, 43 x 24 in. (109.2 x 61 cm).
Pennsylvania Academy of the Fine Arts, Philadelphia.

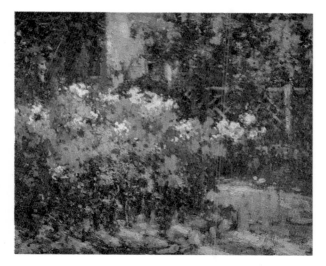

HUGH BRECKENRIDGE (1870–1937).
The Flower Garden, c. 1906. Oil on canvas, 25 x 30 in.
(63.5 x 76.2 cm). Warren Snyder Collection.

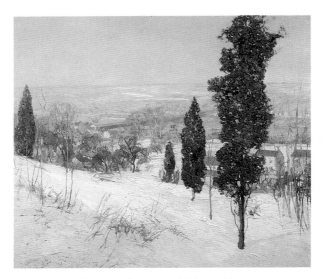

EDWARD REDFIELD (1869–1965).
Cedar Hill, c. 1909. Oil on canvas, 50 x 56 in.
(127 x 142.2 cm). Private collection, Hoboken, New Jersey.

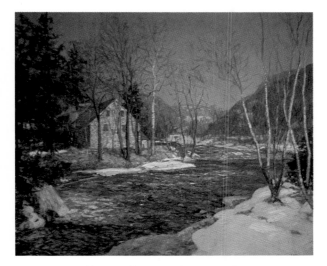

EDWARD REDFIELD (1869–1965).
Pennsylvania Mill, late 1930s. Oil on canvas, 50 x 56 in.
(127 x 142.2 cm). Laurent Redfield.

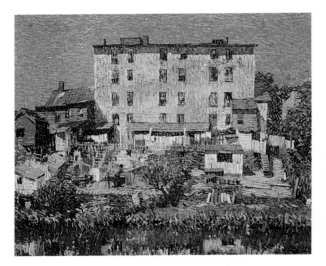

ROBERT SPENCER (1879–1931).
White Tenements, 1913. Oil on canvas, 30 x 36¼ in.
(76.2 x 92.1 cm). The Brooklyn Museum.

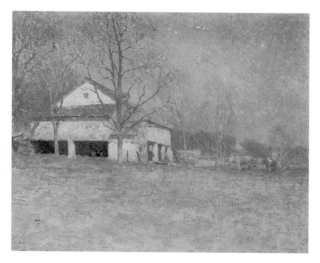

N. C. WYETH (1882–1945).
Pyle's Barn, 1921. Oil on canvas, 25 x 30 in. (63.5 x 76.2 cm).
Private collection.

Daniel Garber (1880–1958).
Tanis, 1915. Oil on canvas, 60 x 46¼ in. (152.4 x 117.5 cm).
The Warner Collection of Gulf State Paper Corporation,
Tuscaloosa, Alabama.

DANIEL GARBER (1880–1958).
The Hawk's Nest, n.d. Oil on canvas, 52 x 56 in.
(132.1 x 142.2 cm). Cincinnati Art Museum.

GARI MELCHERS (1860–1932).
Unpretentious Garden, 1906–10. Oil on canvas, 33½ x 40¼ in.
(85.1 x 102.2 cm). Telfair Academy of Arts and Sciences,
Savannah, Georgia.

GARI MELCHERS (1860–1932).
Young Woman Sewing, c. 1923. Oil on canvas, 34¼ x 29¼ in.
(87 x 74.3 cm). Belmont, The Gari Melchers
Memorial Gallery, Fredericksburg, Virginia.

KATE FREEMAN CLARK (1874–1957).
Shinnecock Hills, c. 1902. Watercolor on paper, 38 x 34 in.
(96.5 x 86.4 cm). Marshall County Historical Society,
Holly Springs, Mississippi.

GRANVILLE REDMOND (1871–1935).
California Landscape with Poppies, c. 1925. Oil on canvas,
30⅛ x 40 in. (76.5 x 101.6 cm). Bancroft Library,
University of California, Berkeley.

Julian Onderdonk (1882–1922).
Bluebonnet Field, 1912. Oil on canvas, 20 x 30 in.
(50.8 x 76.2 cm). San Antonio Museum of Art.

237

EDWARD POTTHAST (1857–1927).
Sunshine, 1889. Oil on canvas, 31⅛ x 25⅝ in. (79 x 65.3 cm).
Cincinnati Art Museum.

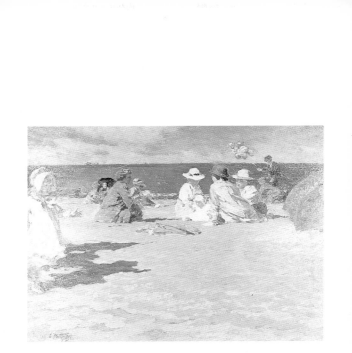

EDWARD POTTHAST (1857–1927).
The Balloon Vendor, c. 1910. Oil on canvas, 30 x 40 in.
(76.2 x 101.6 cm). Mr. and Mrs. Merrill J. Gross.

EDWARD POTTHAST (1857–1927).
At the Beach, n.d. Oil on board, 5 x 7 in. (12.7 x 17.8 cm). The Warner Collection of Gulf State Paper Corporation, Tuscaloosa, Alabama.

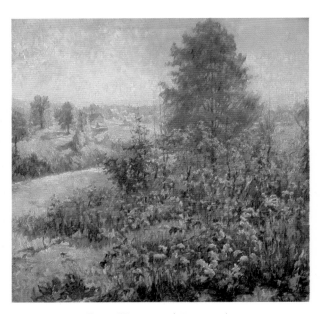

LUCIE HARTRATH (1868–1962).
Autumn Pageant, n.d. Oil on canvas, 42 x 42 in.
(106.7 x 106.7 cm). Union League Club of Chicago.

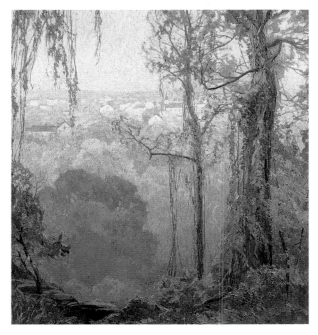

CARL KRAFFT (1884–1938).
The Mystic Spell, c. 1915. Oil on canvas, 46 x 43 in.
(116.8 x 109.2 cm). Barbara Millhouse.

LAWRENCE MAZZANOVICH (c. 1872–1959).
New Hampshire, Opus I, c. 1910. Oil on canvas,
30 x 30 in. (76.2 x 76.2 cm).
Glensheen, University of Minnesota, Duluth.

FREDERIC CLAY BARTLETT (1873–1953).
Blue Rafters, 1919. Oil on canvas, 28 x 30½ in.
(71.1 x 77.5 cm). The Art Institute of Chicago.

ALEXANDER GRINAGER (1864–1949).
Boys Bathing, 1894. Oil on canvas, 34 x 59 in.
(86.4 x 149.9 cm). The Minneapolis Institute of Arts.

245

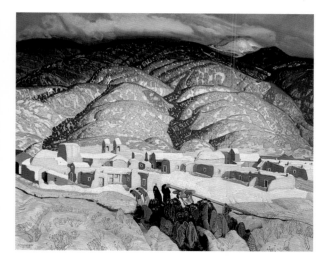

ERNEST BLUMENSCHEIN (1874–1960).
Sangre de Cristo Mountains, 1925. Oil on canvas, 50 x 60 in.
(127 x 152.4 cm). The Anschutz Corporation, Denver.

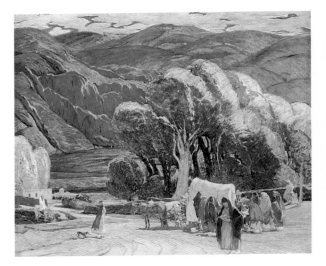

OSCAR BERNINGHAUS (1874–1950).
Apache Visitors, n.d. Oil on canvas, 35⅛ x 40 in.
(89.2 x 101.6 cm). Harrison Eiteljorg Collection.

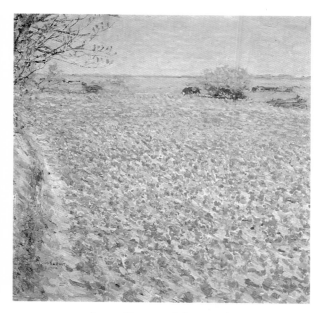

JOSEPH RAPHAEL (1872–1950).
Tulip Field, Holland, 1913. Oil on canvas,
30½ x 30 in. (77.5 x 76.2 cm).
Stanford University Museum of Art, Stanford, California.

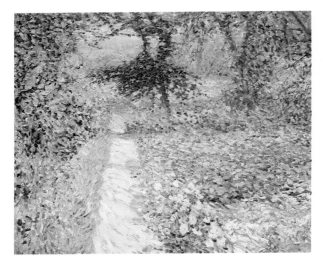

JOSEPH RAPHAEL (1872–1950).
The Garden, c. 1913–15. Oil on canvas, 28¼ x 30¼ in.
(71.8 x 76.8 cm). John Garzoli.

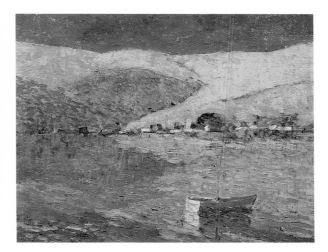

SELDEN GILE (1877–1947).
Boat and Yellow Hills, n.d. Oil on canvas, 30½ x 36 in.
(77.5 x 91.4 cm). The Oakland Museum, Oakland, California.

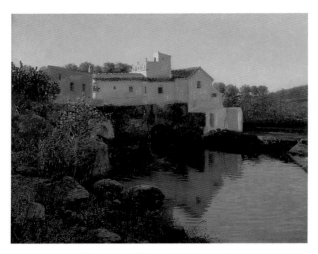

THEODORE WORES (1860–1939).
Ancient Moorish Mill, Spain, 1903. Oil on canvas,
29 x 36 in. (73.7 x 91.4 cm).
Saint Francis Memorial Hospital, San Francisco.

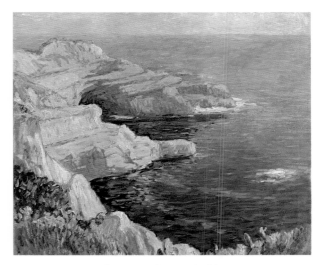

BENJAMIN BROWN (n.d.).
Jewelled Cove, c. 1923. Oil on canvas, 34 x 36 in.
(86.4 x 91.4 cm). Martin and Brigitte Medak.

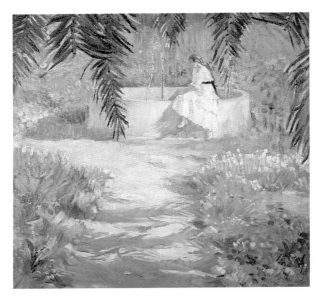

Donna Schuster (1883–1953).
The Fountain, 1917. Oil on canvas, 35 x 34 in.
(88.9 x 86.4 cm). Mr. and Mrs. Robert Hunt.

WILLIAM WENDT (1865–1946).
Emerald Bay, Laguna Beach, 1901. Oil on canvas, 30 x 40 in.
(76.2 x 101.6 cm). Kenneth Lux Gallery, New York.

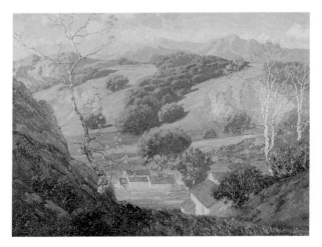

MAURICE BRAUN (1877–1941).
California Valley Farm, c. 1920. Oil on canvas, 40 x 50 in.
(101.6 x 127 cm). Joseph L. Moure.

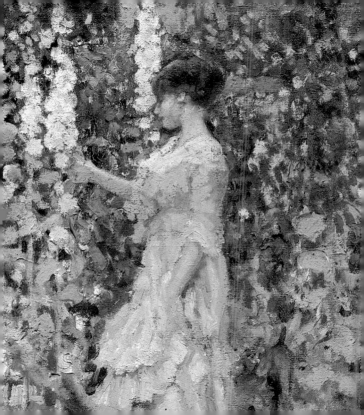

GIVERNY: THE SECOND GENERATION

Many new American artists began to descend on Monet's village during the 1890s. This transitional group between the first and second generation of Americans—including Frederick and Mary Fairchild MacMonnies, Will Low, and William de Leftwich Dodge—were not Impressionists, but they introduced the primary themes that became standard for the younger artists: the figure in the garden and the nude.

Frederick Frieseke, a Chicago native, went to Giverny in 1900 and became most representative of the aesthetic that developed. His large, rounded figures resemble those by Auguste Renoir, and this emulation signified a general shift in emphasis from landscape to the figure within the landscape. Light and sunshine were Frieseke's principal concerns, and he painted many of his models in his own colorful garden. Avowed Impressionists, Frieseke and his Giverny colleagues took a more decorative approach to the style—an approach that was to dominate in the twentieth century.

All of the second-generation Giverny painters were committed to the feminine subject, especially Richard

Miller. His early city scenes were muted in tonality; later, working outdoors, he painted women in sun-flecked environments in full Impressionist chromaticism. The Chicago painter Lawton Parker, a celebrated portraitist, went to Giverny in 1903 and also began to paint figures, nude or clothed, in flowering gardens and under intense sunlight. Many other Chicago-trained painters arrived in Giverny during the next decade, including Karl Anderson (brother of the playwright Sherwood Anderson) and Louis Ritman, who worked partially in Frieseke's manner. In Ritman's works paint is often laid down in blocks of pure color; figures are precisely rendered while the floral environment is described in splotches.

The California painter Guy Rose had been in Giverny as early as 1890. Returning in 1904, he worked in the earlier tradition of Giverny. He painted misty scenes along the Epte, rather than figures in blazing sunlight and bright garden scenes. Calling themselves "The Giverny Group," Anderson, Frieseke, Miller, Parker, Rose, and Edmund Greacen exhibited together in New York in 1910. Radiant gardens, parasols, and the nude were identifying features of their works, all depicted in the brilliant warmth of summer sunlight.

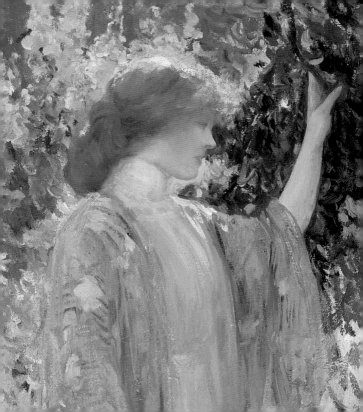

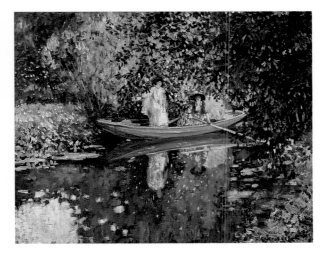

FREDERICK FRIESEKE (1874–1939).
Two Ladies in a Boat, c. 1905. Oil on canvas, 41 x 73⅞ in.
(104.1 x 187.7 cm). Private collection.

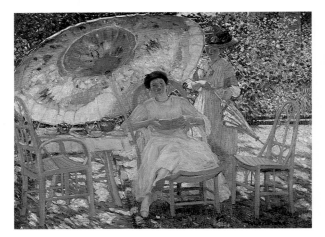

FREDERICK FRIESEKE (1874–1939).
The Garden Parasol, c. 1909. Oil on canvas, 57⅛ x 77 in.
(145 x 195.6 cm). North Carolina Museum of Art, Raleigh.

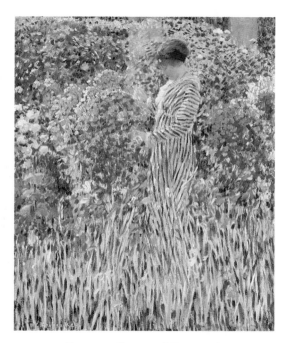

FREDERICK FRIESEKE (1874–1939).
Lady in a Garden, c. 1912. Oil on canvas, 31⅞ x 25¾ in.
(81 x 65.4 cm). Daniel J. Terra Collection.

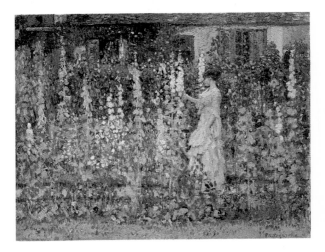

FREDERICK FRIESEKE (1874–1939).
Hollyhocks, c. 1914. Oil on canvas, 25½ x 32 in.
(64.8 x 81.3 cm). National Academy of Design, New York.

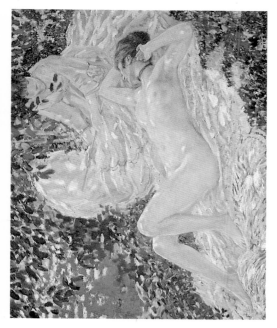

FREDERICK FRIESEKE (1874–1939).
Summer, 1914. Oil on canvas, 45 x 57¾ in. (114.3 x 146.7 cm).
The Metropolitan Museum of Art, New York.

FREDERICK FRIESEKE (1874–1939).
Autumn, 1914. Oil on canvas, 38 x 51½ in. (97 x 131 cm).
Museo d'Arte Moderna di Ca'Pesaro–Venezia, Venice.

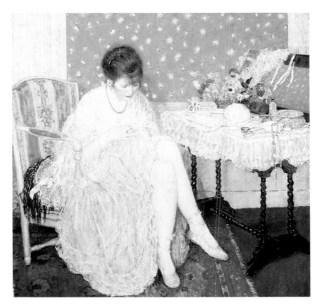

FREDERICK FRIESEKE (1874–1939).
Torn Lingerie, 1915. Oil on canvas, 51¼ x 51¾ in.
(130.2 x 131.5 cm). The Saint Louis Art Museum.

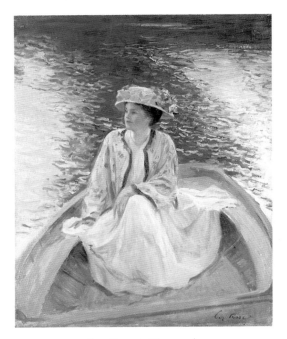

GUY ROSE (1867–1925).
On the River, c. 1908. Oil on canvas, 23¾ x 19 in.
(60.3 x 48.3 cm). Rose Family Collection.

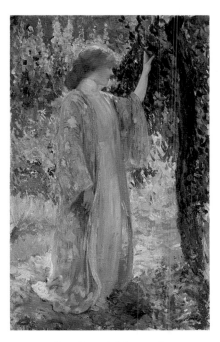

GUY ROSE (1867–1925).
The Blue Kimono, c. 1909. Oil on canvas, 31 x 19 in.
(78.7 x 48.3 cm). Terry and Paula Trotter; Trotter Galleries.

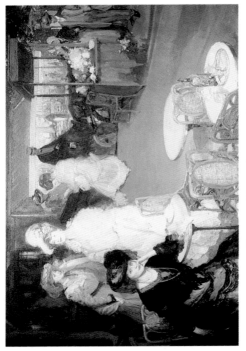

RICHARD MILLER (1875–1943).
L'Heure de l'apéritif (Café de nuit), 1906.
Oil on canvas, 48½ x 67⅜ in. (123.2 x 171.2 cm).
Dr. and Mrs. Henry C. Landon, III.

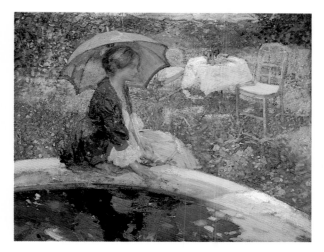

RICHARD MILLER (1875–1943).
The Pool, c. 1906–11. Oil on canvas, 32 x 39½ in.
(81.3 x 100.2 cm). Terra Foundation for the Arts.

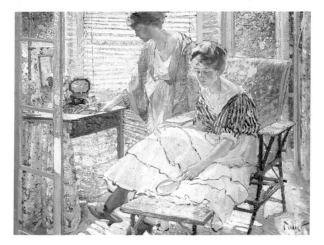

RICHARD MILLER (1875–1943).
Sunlight, c. 1913. Oil on canvas, 45 x 57½ in.
(114.3 x 146.1 cm). The Art Institute of Chicago.

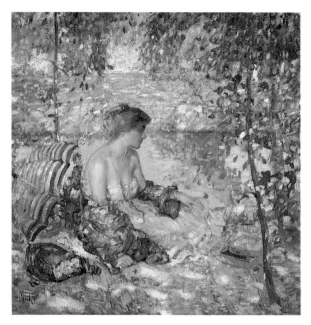

RICHARD MILLER (1875–1943).
Sylvan Dell, or Reverie, c. 1916–18. Oil on canvas,
36 x 34 in. (91.4 x 86.4 cm).
Museum of Art, Rhode Island School of Design, Providence.

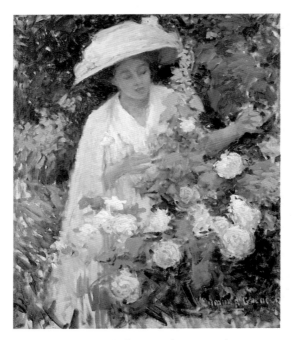

EDMUND W. GREACEN (1876–1949).
Ethol with Roses, 1907. Oil on canvas, 25¾ x 21 in.
(65.4 x 53.3 cm). John M. Strange, Houston.

EDMUND W. GREACEN (1876–1949).
River Epte, 1907. Oil on canvas, 26 x 32 in. (66 x 81.3 cm).
Private collection; Courtesy of Spanierman Gallery, New York.

EDMUND W. GREACEN (1876–1949).
The Old Garden, c. 1912. Oil on canvas, 30¼ x 30¼ in. (76.8 x 76.8 cm).
Lyme Historical Society, Florence Griswold Museum,
Old Lyme, Connecticut.

ALSON SKINNER CLARK (1876–1949).
Summer, Giverny, 1910. Oil on canvas, 25⅝ x 31⅞ in.
(65.1 x 81 cm). Mr. and Mrs. Thomas B. Stiles II.

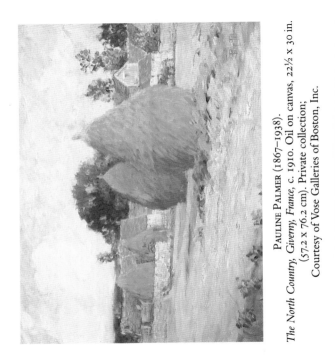

PAULINE PALMER (1867–1938).
The North Country, Giverny, France, c. 1910. Oil on canvas, 22½ x 30 in.
(57.2 x 76.2 cm). Private collection;
Courtesy of Vose Galleries of Boston, Inc.

277

IMPRESSIONISM AND
THE NEW GENERATION

By the early twentieth century Impressionism had proved itself and, inevitably, new movements challenged it as outmoded. Art during this period took two primary new directions: a reinvigorated realism concentrated on city life and a formalist modernism related to such European movements as Post-Impressionism, Fauvism, and Cubism.

The urban realists coalesced around the Eight, a group of painters led by Robert Henri. Among the Eight it was Ernest Lawson who maintained the closest contact with American Impressionists through his study with J. Alden Weir and especially John Twachtman. William Glackens, another member of the Eight, also maintained an allegiance to Impressionism. His early New York scenes were first likened to the art of Edouard Manet, then to Edgar Degas's painting. Around 1912 Glackens entered his Renoir phase, producing paintings that feature the soft, feathery brushwork and rich, variegated colorism associated with that artist.

The most original among the Impressionist-related artists of the Eight was Maurice Prendergast, who

achieved great success with his joyful, sunlit watercolors of Boston and his brilliant Venice paintings. He took readily to Post-Impressionism and was one of the first Americans to appreciate Paul Cézanne.

Most of the young painters involved with European modernism went through at least a brief stage of Impressionism. Among those who studied with William Merritt Chase was Marsden Hartley, who adopted Chase's broad, active brushstrokes even though he rejected Chase's emphasis on technical virtuosity. Hartley's first mature style was a Neo-Impressionist technique derived from the Italian artist Giovanni Segantini.

Even after Impressionism had achieved primacy in American art by the mid-1890s, it continued to generate a great deal of critical discussion. Tonalists such as Henry Ward Ranger disparaged Impressionism as an art concerned primarily with technique, but even Ranger acknowledged its universality. Critics stressed the Americanness of Impressionism, however much of it had originated abroad. And in 1915 Louis Weisberg described the technical aspects of Impressionist painting as manifestations of the kaleidoscopic nature of an age dominated by change; thus Impressionism was not only enshrined as a historical phase of American art but it was also recognized as a reflection of contemporary life.

ERNEST LAWSON (1873–1939).
Harlem River, c. 1910. Oil on canvas, 25 x 30 in.
(63.5 x 76.2 cm). The Newark Museum, Newark, New Jersey.

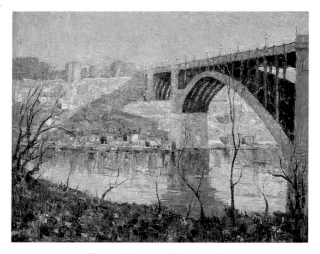

ERNEST LAWSON (1873–1939).
Spring Night, Harlem River, 1913. Oil on canvas
mounted on panel, 25⅛ x 30⅛ in. (63.8 x 76.5 cm).
The Phillips Collection, Washington, D.C.

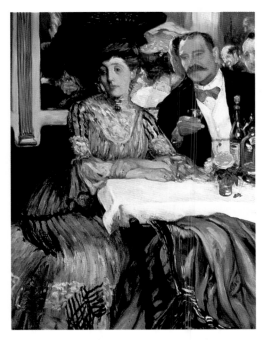

WILLIAM GLACKENS (1870–1938).
Chez Mouquin, 1905. Oil on canvas, 48 x 39 in.
(121.9 x 99.1 cm). The Art Institute of Chicago.

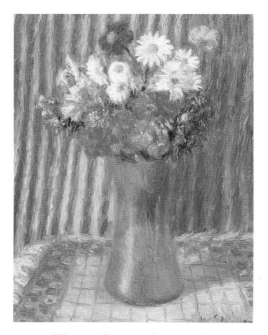

WILLIAM GLACKENS (1870–1938).
Still Life, Flowers in a Vase, n.d. Oil on canvas, 20 x 15 in.
(50.8 x 38.1 cm). Private collection.

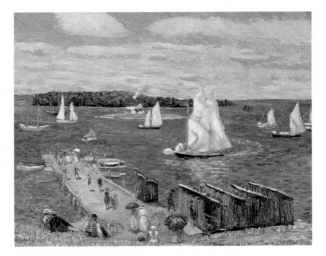

WILLIAM GLACKENS (1870–1938).
Mahone Bay, 1911.
Oil on canvas, 26¼ x 31¾ in. (66.7 x 80.6 cm).
University of Nebraska Art Galleries, Lincoln.

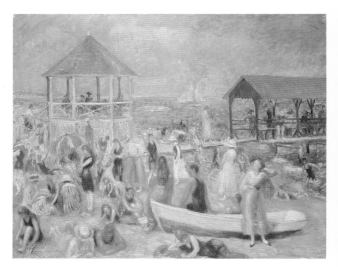

WILLIAM GLACKENS (1870–1938).
Beach Scene, near New London, 1918.
Oil on canvas, 26 x 31⅞ in. (66 x 81 cm).
Columbus Museum of Art, Columbus, Ohio.

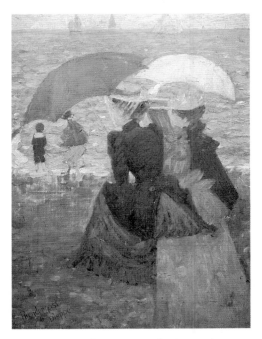

MAURICE PRENDERGAST (1861–1924).
Dieppe, 1892. Oil on canvas, 13 x 9½ in. (33 x 24.1 cm).
Whitney Museum of American Art, New York.

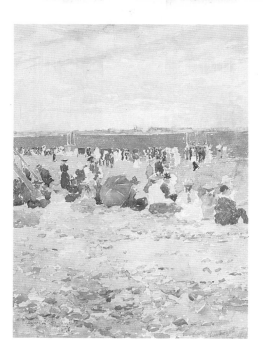

MAURICE PRENDERGAST (1861–1924).
Revere Beach, 1896. Watercolor and pencil on paper,
13⅝ x 9⅞ in. (34.5 x 25.2 cm). The Saint Louis Art Museum.

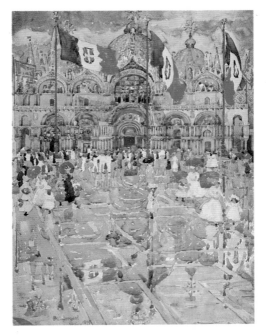

MAURICE PRENDERGAST (1861–1924).
Square of San Marco, Venice, 1899. Watercolor and pencil on
paper, 19¾ x 14¼ in. (50.2 x 36.2 cm). Mrs. Alice M. Kaplan.

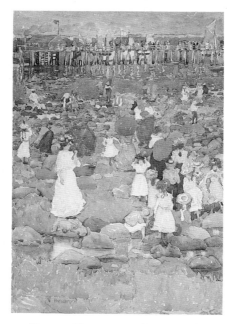

MAURICE PRENDERGAST (1861–1924).
Stony Beach, Ogunquit, c. 1900–1901.
Watercolor on paper, 20⅞ x 13⅞ in. (53.1 x 35.3 cm).
Mr. and Mrs. Arthur G. Altschul.

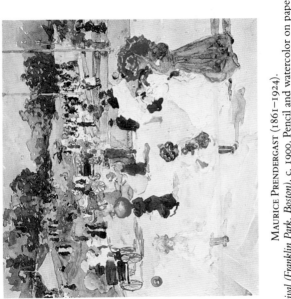

MAURICE PRENDERGAST (1861–1924).
Carnival (Franklin Park, Boston), c. 1900. Pencil and watercolor on paper,
13 x 14½ in. (33 x 36.8 cm). Museum of Fine Arts, Boston.

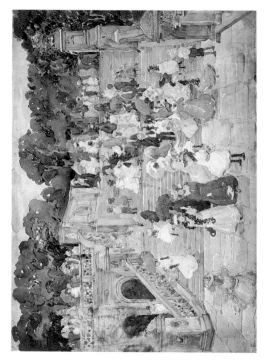

MAURICE PRENDERGAST (1861–1924).
The Mall, Central Park, 1901. Watercolor on paper,
15¼ x 22½ in. (38.7 x 57.2 cm). The Art Institute of Chicago.

MAURICE PRENDERGAST (1861–1924).
Landscape with Figures, c. 1912. Oil on canvas, 29¾ x 42¾ in.
(75.6 x 108.9 cm). Munson–Williams–Proctor Institute, Utica, New York.

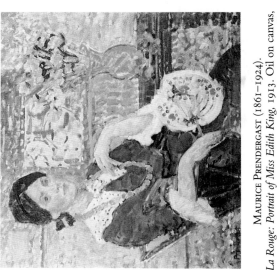

MAURICE PRENDERGAST (1861–1924).
La Rouge: Portrait of Miss Edith King, 1913. Oil on canvas,
27¾ x 30½ in. (70.5 x 77.5 cm). Lehigh University Art Galleries,
Bethlehem, Pennsylvania.

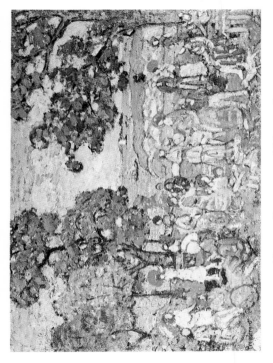

MAURICE PRENDERGAST (1861–1924).
Promenade, n.d. Oil on canvas, 28 x 40⅛ in. (71.1 x 101.9 cm).
Columbus Museum of Art, Columbus, Ohio.

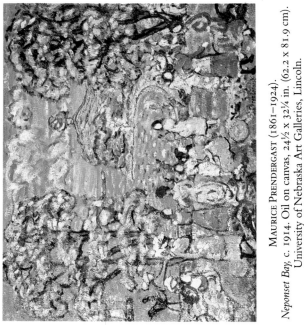

MAURICE PRENDERGAST (1861–1924).
Neponset Bay, c. 1914. Oil on canvas, 24½ x 32¼ in. (62.2 x 81.9 cm).
University of Nebraska Art Galleries, Lincoln.

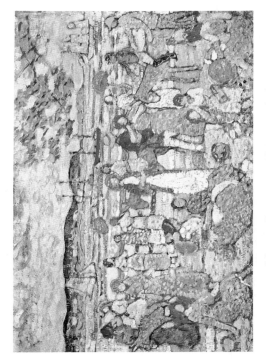

MAURICE PRENDERGAST (1861–1924).
Along the Shore, c. 1916. Oil on canvas, 23¼ x 34 in. (59.1 x 86.4 cm).
Columbus Museum of Art, Columbus, Ohio.

MAURICE PRENDERGAST (1861–1924).
Picnic by the Inlet, 1916. Oil on canvas, 28¼ x 24⅝ in.
(71.8 x 62.5 cm). Mr. and Mrs. Raymond J. Horowitz.

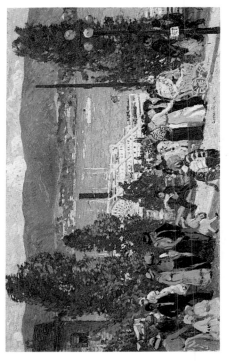

GIFFORD BEAL (1879–1956).
The Albany Boat, 1915. Oil on canvas, 36⅜ x 60¼ in. (92.5 x 153 cm).
The Metropolitan Museum of Art, New York.

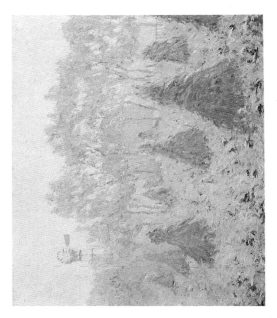

ALLEN TUCKER (1866–1939).
Cornshucks and Wind Mill, 1909. Oil on canvas, 30 x 36 in.
(76.2 x 91.4 cm). The Newark Museum, Newark, New Jersey.

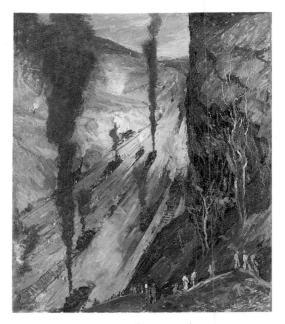

JONAS LIE (1880–1940).
The Conquerors: Culebra Cut, Panama Canal, 1913.
Oil on canvas, 59¾ x 49⅞ in. (151.8 x 126.8 cm).
The Metropolitan Museum of Art, New York.

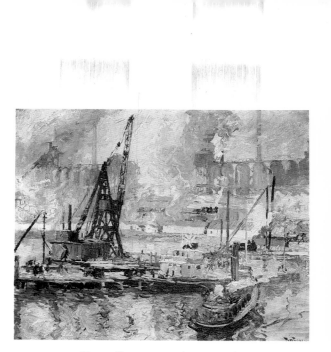

Henry Reuterdahl (1871–1925).
Blast Furnaces, 1912. Oil on canvas, 32⅛ x 39⅞ in.
(81.5 x 101.4 cm). The Toledo Museum of Art, Toledo, Ohio.

MARSDEN HARTLEY (1878–1943).
Carnival of Autumn, 1908–9. Oil on canvas, 30¼ x 30⅛ in.
(76.8 x 76.5 cm). Museum of Fine Arts, Boston.

MARSDEN HARTLEY (1878–1943).
The Mountains, 1909. Oil on canvas,
30 x 30⅛ in. (76.2 x 76.5 cm).
Columbus Museum of Art, Columbus, Ohio.

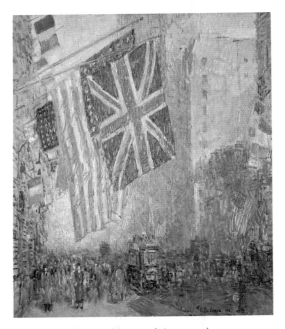

CHILDE HASSAM (1859–1935).
The Union Jack, New York, April Morn, 1918. Oil on canvas,
36 x 30⅛ in. (91.4 x 76.5 cm). Hirshhorn Museum and
Sculpture Garden, Smithsonian Institution, Washington, D.C.

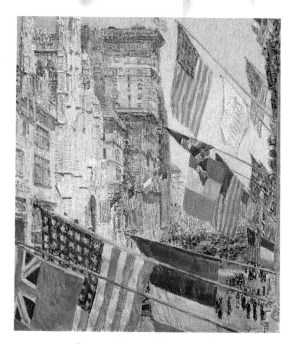

CHILDE HASSAM (1859–1935).
Allies Day, May 1917, 1917. Oil on canvas, 36¾ x 30¼ in.
(93.3 x 76.8 cm). National Gallery of Art, Washington, D.C.

INDEX OF DONORS' CREDITS

*Names are alphabetized according to the donor's last name;
numerals refer to page numbers.*

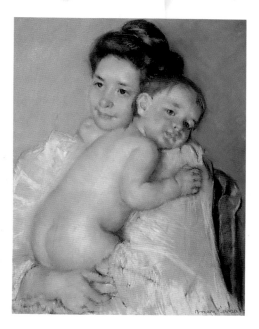

MARY CASSATT (1845–1926).
Mother Berthe Holding Her Baby (The Young Mother), 1900.
Pastel on paper, 22½ x 17¼ in. (57.1 x 43.8 cm).
Private collection.

LILLA CABOT PERRY (1848–1933).
Japan, 1900. Oil on canvas, 17¾ x 21¾ in. (45.1 x 55.3 cm).
Coggins Collection of American Art.

INDEX OF ILLUSTRATIONS

316

317

SELECTED **TINY FOLIOS**™ FROM ABBEVILLE PRESS